PAT STEIR PAINTINGS

PAT STEIR PAINTINGS

Essay/Interview by Carter Ratcliff

Harry N. Abrams, Inc., Publishers, New York

Project Director: Andreas Landshoff
Editor: Phyllis Freeman

Library of Congress Cataloging-in-Publication Data

Steir, Pat, 1940–
 Pat Steir.

 Bibliography: p. 115
 1. Steir, Pat, 1940– . I. Ratcliff, Carter.
II. Title.
N6537.S713A4 1986 760′.092′4 85-20143
ISBN 0–8109–1503–0
ISBN 0–8109–2316–5 (pbk.)

Published in 1986 by Harry N. Abrams, Incorporated, New York

Printed and bound in Japan

The artist gratefully acknowledges the support of General Mills, Minneapolis

CONTENTS

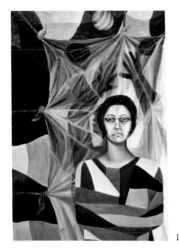

CARTER RATCLIFF: For nearly two decades, Pat Steir floated in an atemporal realm of her own devising, an imaginary place where she sought, and nearly always found, whatever she needed to sustain her art. In recent seasons, that has changed. She has found her way to a vision of history. Images, styles, aesthetic possibilities once drifted free in her art. Now a temporal order brings coherence. Steir's paintings have become emblems of an individual fully conscious of the larger history that encloses the history of art. Early in the last century, Henry Fuseli had this suggestion for young artists: "Transpose *yourself* into your subject." His advice has often been taken. Steir, too, makes art about herself. She is one of the few who knows as well how to place her self-image in the currents of personal time and cultural history.

So far there have been three stages in Steir's development, each with its own presiding presence. Now it is Rembrandt. At the previous stage, the tutelary figure was not an artist but an object, an emblem of a way of seeing: the camera. At the outset, Carl Jung oversaw her progress. Rembrandt, Jung, and the spirit of photography—these three make an odd assortment. And other figures, other spirits, have hovered in the vicinity of Pat Steir's art. As we will see, these range from the theorists of Conceptual Art to the rationalists of the eighteenth-century Enlightenment, from the originators of aesthetic thought in the West to the tribal shamans of a non-Western culture.

Pat Steir studied art during the mid-1950s. Though the world of New York art was coming out of a deep and long-lasting obscurity, it had not yet become as glamorous as it is today. Nonetheless, the pressures of fashion had begun to build. Robert Motherwell and other heroes of the New York School's first generation had learned much from the Surrealists, who in turn derived their methods of automatism from Freudian theory. So Sigmund Freud enjoyed a certain fashionableness in those days. Pat Steir was drawn to Carl Jung. She was not defiant of fashion, just indifferent to it. She immersed herself, as if entranced, in Jung's repertory of archetypal symbols—as if, in the depths of her own experience, universal truths waited to be uncovered. Steir had no eye for the fads and fashions, the trends and opportunities, that appeared all around her in the fifties. Her Jung was not a figure defending an embattled position in the history of psychoanalysis but a private shaman she discovered—and invented—in the

1. *Self-Portrait.* 1957. Private collection
2. *Woman.* 1957. Collection James Starrett
3. *Self-Portrait.* 1958. Destroyed

course of her study. He presided over her early self-enchantment.

PAT STEIR: I always made drawings as a child. When I began to make paintings at art school, I pulled a great deal of my child world into my work. I was sixteen years old, a very young art student in the midst of adolescence. My main interest was my own suffering—my inward self. I read Jung in those days, and I felt his writings helped me with my research into myself. Later on, my art changed drastically because my idea of research changed. New methods created new subjects. But in the beginning I was the researcher and the researched, the mystery and the one destined to unravel the mystery. That is what my art was for, to record that unraveling.

Hanging Puppet Figure is probably the first oil painting I ever did. It must be from about 1958. Beyond its autobiographical content, what interests me in this painting is the presence of two kinds of painting in a single canvas. I used fast brushwork to produce abstract imagery, then tight brushwork to build the figurative forms. Now I move consciously from style to style within a single work. Then I was not so conscious, not so deliberate. And, the two kinds of painting had a symbolic meaning for me. They stood for two worlds, inner and outer, though I didn't distinguish them in the usual way.

The Abstract Expressionists, who were fundamental to my conception of painting, I believe, used abstraction to try to reach an inner and a truer reality—a reality unavailable to realism, to figurative painting. I respected them and their work. When I found out that Philip Guston taught a class at my school, I fought and fought to get into it. I discovered that he spent the entire class reading Time magazine. De Kooning was an important figure then, but I didn't like what seemed like all that splashing of his. I wasn't physical enough to develop an Action Painter's style. All of the other students were using enormous brushes. I didn't. Because I couldn't. I just didn't have that physicality. More important, I thought abstraction was just one aspect of art. And it seemed to me that abstract, "messy" images belong to the outer, not the inner world. So I reversed the Abstract Expressionist premises.

4. *Hanging Puppet Figure.* 1958. Destroyed
5. *Woman Running into and away from Her Dreams.* 1958. Whereabouts unknown
6. *Mostly Female Hermaphrodite Embracing Her Unknown Dreams.* 1958. Whereabouts unknown

7. *Self Breaking Free*. 1958. Destroyed
8. *Woman Looking at Her Reflection*. 1960. Destroyed
9. *Woman Smelling a Flower with Unusual Difficulty*. 1960 or 1961. Whereabouts unknown

10. *Two Babies*. 1958. Destroyed
11. *Self*. 1964. Destroyed
12. *Sideways Crying Lady*. 1961. Collection Nancy Grossman

13. *Girl on a Swing*. 1963. Destroyed
14. *Motorcycle Rider*. 1958 or 1959. Destroyed
15. *Self-Portrait*. 1958 or 1959. Destroyed

This was not a deliberate strategy. I was guided by my reading of Jung but I was never a conscious strategist. I felt that if the themes of my early paintings, those very specific psychological concerns, were as significant as I thought they were, then I had a rationale for figurative painting. That was a time when a figure painter needed a justification for not doing Abstract Expressionism. Woman Looking at Her Reflection, from 1958 or '60, shows the figure of the "self," of my self, as a clearly drawn, linear figure. The shadow in the water, the murkiness, is herself at a distance—out there, outside herself.

A little later Lady Running from Ghosts into the Unknown shows a "Jungian" woman haunted by symbols of her unconscious being—those are the ghosts. She tries to escape into a messy, unknown, abstract present. Abstraction symbolized immediate experience for the Abstract Expressionists. It did just the opposite for me. Since I was so obsessed with myself, so troubled by my relation to a world that seemed vague or even chaotic, it was natural that a so-called figurative style—a style that could give me an image of myself—would seem more immediate. An abstract style suggested a world more distant, a world I wanted to reach. The tight, so-called figurative style that appears in parts of these early paintings reminds me of Richard Lindner, one of my teachers.

Those issues of style were not as important to me as they were to painters more in tune with the current scene. I wasn't fully awake to the world in that period of my life. When I did get around to thinking about art questions, they were blurred, out-of-focus. Through all of the time I've been an artist I have felt what I feel now: every depiction of reality is an abstraction, whatever the "style," because to depict or picture anything requires abstract thinking. Photos and films are abstractions too, though drawing and painting are especially so.

Say you draw a picture of your own face. It takes an enormous amount of abstract thinking to get your hand to do what you want it to do. And the result is a visual abstraction made from the tangible reality of your face. So there is a great deal of abstraction involved in that self-image. It's the same with any image an artist makes. They are all abstraction from the self. They all reflect that artist's sense of self. All art is figurative, in a certain way. Even the Minimalists and the Conceptualists, whose objectivity brought me out of my first, "Jungian" stage, produce self-portraits. They reveal themselves even in their handwriting or in the way they arrange a typewritten text on the page. I didn't believe this when I was first drawn to their work. I saw them as impersonal—distinctive figures, of course, but able to overcome the peculiarities of the self. I saw that as liberating. It was liberating, for me, all that severity of the 1960s and early '70s. Later I saw that a Minimalist grid is as much a self-portrait as a painting of one's face.

But every figure of the self is a disguise. Everything humans make is an attempt to make a mirror. The face in a painting is a mask. It covers a reality that is ultimately ungraspable. The figure in Woman Sitting in a Chair covers her face with her hands. A blob of paint is coming at her. Paint-as-paint, paint-as-blood, paint-as-an-assault. In all of these canvases I tried to resolve the conflict between being a woman and struggling to make art. I threw the paint like a baseball, wads of paint. I was about twenty years old when I made this. The Terry Dintenfass Gallery showed it in 1964. The canvas no longer exists. I destroyed it when I was moving. I said, "Oh, this painting isn't very good. I can do better paintings." I wish I had all the works I did then.

I suppose I was twenty-one or twenty-three when I painted Sideways Crying Lady. This is the only one of the early paintings that still exists. A friend bought it. I was like a late medieval painter when it came to the colors of shadows. That was my biggest question: what color should they be? I hadn't gotten to Gauguin yet. I hadn't resolved my questions about being female and being an artist. My only clear thought on the subject was that a true artist is a total original. So if I was totally original, totally true to myself and independent of what was going on around me, my doubts would disappear. I would simply be an artist, the way a natural phenomenon is what it is—naturally.

Despite this ideal of complete integrity, of art absolutely at one with itself, my earliest paintings show that I was satisfied only when I could see a kaleidoscope of possibilities. That's why I could never keep abstraction out of my figurative works.

16

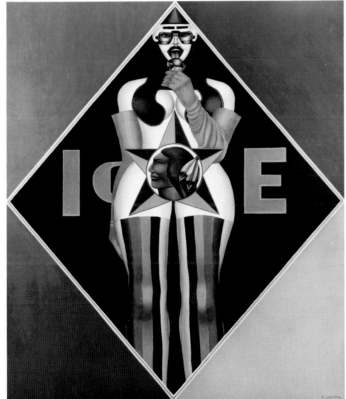

17

In this primitive state of nature, when mankind begin to unite in society, the manners, sentiments, and passions are (if we may use the expression) perfectly original. They are the dictates of nature, unmixed and undisguised....
—William Duff, *An Essay on Original Genius*, 1767

CARTER RATCLIFF: William Duff, Edward Young, and their colleagues advanced the cause of the individual artist's singularity against the Neoclassical certainties, the academic rules, of the Augustan Age. These eighteenth-century writers bequeath us the ideal of an artist who accepts no exterior authority of any kind; an artist who simply and naturally *is* an artist. Jung's theory of a collective unconscious, a birthright of universal symbols, helped Steir see herself as this natural, completely original sort of artist.

Jungian archetypes aside, the untutored genius is one of our culture's most persistent images. We learn it unconsciously, and this unconsciousness helps sustain our belief in the possibility of utterly spontaneous art. Indifferent to art-world fashion and its obvious artifice, Pat Steir was particularly susceptible to the modern faith in originality. To be an artist she needed only to be herself. Jung would reveal the vehicles, the universal forms, capable of bearing the singular meanings of her life to an audience of which she had only the vaguest idea. If the artist was a natural phenomenon, why shouldn't the audience be the same? It was necessary only to persist in the struggle to get in touch with her originality, her innate power as an artist. Yet even at her most thoroughly entranced, Steir knew that matters were not this simple.

Her teachers, Philip Guston and Richard Lindner, worked in opposed styles. If art is a matter of making contact with one's individuality, then finding a way to express one's singular being to an audience, there was an obvious explanation for the differences between these older artists. Each possessed his own degree of originality. Each worked in his own manner. But Guston's Abstract Expressionism was not his alone. He belonged to a group of painters then in the ascendant. Lindner's figures made him a loner with a comparatively skimpy audience. Steir sensed that a style could be a matter of an artist's public allegiance as well as an expression of an inward self. Moreover, Guston drew energy from his membership in a band of artists. To share a style with other artists was not

16. Philip Guston. *Native's Return*. 1957. Oil on canvas, 64⅞ x 75⅞". The Phillips Collection, Washington, D.C.

17. Richard Lindner. *Ice*. 1966. Oil on canvas, 70 x 60". Collection Whitney Museum of American Art, New York. Gift of the Friends of the Whitney Museum of American Art

necessarily a debilitating compromise.

Steir noted too that her own tastes did not line up neatly with those of the art world. Lindner's art meant far more to her than Guston's did. Whether in art or in the experience of it, the natural and inevitable were matters for debate. And these debates were subject to the pressures of art-world politics. Steir was far more troubled by signs that her own art had generated a debate between the abstract and the figurative. When tensions appeared, she worked them out, but only partially. The same tensions reappeared, again and again, in nearly all her early canvases. Instead of flowing in an unimpeded current, her originality, her impulse to paint, had to be negotiated.

PAT STEIR: I painted Altar in 1968–69. It culminates everything that had gone before. But, like all final steps, it is also the first step in a new direction. The painting has three panels, like so many of my later works. There are two figures, one in each of the side panels. They're like guardians of the doorway, the entrance to the place where I was going. The central panel turned out to be the opening to the future. It has no figures. None of my paintings after that had figures. Or no figures of the symbolic, Jungian kind that had fascinated me ever since I began painting seriously. That symbolic system had begun to decay. I didn't believe in it any longer, all that dark, dusty, overcomplicated rumination on myself.

In the beginning, I saw the world only to the extent that I projected myself onto it—made the world a part of me. Blurring the distinction between myself and the everything else had begun to feel like avoidance. I mean, I knew that there was a difference between me and not-me, of course, but that knowledge didn't get into my art. When I painted I put my own image at the center, with only a shadow or some unnamable passage of abstract brushwork to suggest that there was some mystery other than the mystery of my own being.

I mutilated the guardian figures of Altar, took away their arms, to make them more static. Eventually I took away their legs as well. I wanted them to be immediate presences with a self-evident function. More like icons, less like dream figures. So they would stay right there, on the canvas, and not march off into the Jungian netherworld.

18

19

18. *Altar.* 1968–69. Whereabouts unknown
19. *Signal Altar.* 1968–69. Whereabouts unknown

Around this time a new way of making images had begun to look much more convincing to me—Navajo sand painting. A friend of mine from art school had settled on a Navajo reservation in Arizona as a teacher. In the late sixties I went to live in her house for a while. For the next eight years or so, I spent every August on the reservation. Sometimes I'd go in January too. My friend's house was a little like a loft in New York. I got to know some of the Navajo families, but I never really learned anything about their traditional life—the ceremonies and the myths. Still, the space and the landscape had a strong impact on my painting. New Mexico was open. The Jungian world had been closed. Musty. And the openness of that landscape seemed to belong to the clarity of Navajo symbols. To an outsider those symbols are mysterious, but each has its own meaning, simple and learnable. That attracted me.

When I was painting Altar, I knew the guardian figures were guarding a doorway that would open sooner or later on a new kind of painting. But I didn't know when it would happen. After I finished Altar, I destroyed it. I didn't have enough space to store it, and I felt I'd never miss it. I didn't. But I stopped painting for half a year. I was working at the job I got after finishing art school—as an art director at a publishing house in New York. I had arranged my schedule so that three days of the week were free for my own art. Now that I wasn't painting, I wandered through the streets of New York taking pictures—often of people who were all too eager to be photographed. A camera is magic. People think you're a journalist and you're going to turn them into news.

But I wasn't looking for news. I just wanted to see what the world was beyond the world of my art. I wanted to see what was out there. Traveling to New Mexico, I had seen a different kind of space and light, a different way for images to have meaning. Travel became very important to me during the next few years. I traveled a lot, compulsively. I felt as if I was doing research into the world—the way a child bites the table, to make contact with some other sort of object. Something other than its own body. This research began with the photos I took during the first six months after I finished Altar.

Photography never gave me any images I could incorporate into my paintings. I just wanted to see things in a different way. And finally I did. When I painted Bird in 1969, I thought of it as my first painting. And it was the first in the sense that never before had I made a painting so self-consciously as a painting. Not as an attempt to see into a dark emotional state. Not as a plunge into dream-symbol. None of that. With Bird I was suddenly concerned about the medium as well as the subject. Of course the subject was important to me: a bird in the corner of an imaginary landscape.

A bird had flown into the studio of an artist friend of mine. He made a cage for it—very big, like a piece of sculpture, then he gave it to me. The bird became my lucky bird. Photography, travel, Navajo symbols—I was getting a sense of the openness of the world, and I began to feel free to move things around on the surface of the canvas. To treat it as a surface which I could control. Which I could map. I had released myself from the traditional order of landscape, and now everything seemed much simpler to me. I could represent the medium itself with a series of brushstrokes. After I finished this painting, I went to sleep in a very disturbed state. Had I considered the work of Jasper Johns more carefully, I wouldn't have been so troubled.

Until now I had hardly ever gone to galleries and museums. My friends were literary. I wasn't really involved with the art world. Literature and music were my main interests. I was completely isolated from the art world. With Bird and the paintings that followed after it, I decided that I was a painter, after all, so I left my job in publishing and began to teach painting instead. A friend told me that a curator at the Whitney Museum, Marcia Tucker, would be interested in my work. I got in touch with Marcia, she saw my new canvases, and was interested. More than that. She became an advocate. She introduced me to other artists who were working in a similar way, such as Elizabeth Murray and Lynda Benglis. I saw that what I was doing related to Jasper Johns and his way of seeing images as icons.

Before Bird nothing registered unless it bore directly on my autobiographical obsessions. Now I was conscious of myself—and of art—in a way that wasn't strictly self-referential. I began to see how artists shared certain of their concerns, how generations

20

develop. To make contact with my contemporaries, to see what we all shared with artists of an earlier generation—Jasper Johns, for instance—was part of my struggle to recognize the world beyond the boundaries of myself. There is a flavor of history to all this, but my vision wasn't informed by history until much later. During this period everything was in the present—as always. Only now the present included more than me and my inwardness.

I can't pretend I was completely innocent of any thought of history. I studied the piano from the time I was five years old until I left home, so I had been exposed to the idea that musical styles evolve out of one another, that later composers build on the work of predecessors. Then I heard John Cage's music and I decided there wasn't anything more to be done with music. That particular history was over. Then I went to art school in such a self-absorbed daze that I simply never gave any thought to the history of art.

I named the bird in Bird after John Cage. Actually, "John Cage" was my name for the bird and the cage where he lived. Anyway, I admired Cage because he showed that you're composing even if you tape random noises. The results are music, a composer's work,

21

20. *Bird.* 1969. Whereabouts unknown
21. *Inside.* 1971. Oil on canvas, 84 x 34". Collection
 Ciba-Geigy Corporation, Ardsley, New York
22. *Blue.* 1969–70. Oil on canvas, 48 x 62". Collection
 Arthur and Carol Goldberg, New York

23

23. *Legend.* 1971. Oil on canvas, 84 x 108". Destroyed

because those recorded sounds reflect some method of choice—when to start, when to stop, where to record. Joyce had done something similar with language, or so I thought. So I decided that I would do it in visual art, where, as far as I could see, it hadn't been done—pushing the process so far toward randomness that the artist has to make only the most basic, unavoidable decisions. I wanted nothing but the most minimal, unavoidable matters of procedure to affect the random or—for me, a painter—the unconscious flow of images.

In my post-Jungian state, I wanted to believe that my unconscious was as arbitrary as the sound patterns that John Cage got when he went around taping at random. Later I realized this isn't so. There is nothing arbitrary about the unconscious, even if Jungian archetypes aren't all that helpful in dealing with it. So I couldn't really use John Cage's idea of music as a means of capturing the random. But he was a crucial figure for me. His fields of sound helped as much as photography or the desert of New Mexico to get me out into the world, and then back to the canvas with the freedom to move around in it at will.

Legend, a painting that came right after Bird, contains one of those unfree figures—a figure tied up in the symbolism I had left behind. But all around this image, the canvas was free of formalism. There was no up, no down. I wasn't thinking of Pollock, but I was working toward that allover quality he found by reaching in from every side of the canvas. Cage had put a bell jar over chaos and for a time I wanted to do the same thing. Then I realized that each of us imposes order simply by the way we see. This makes chaos impossible—you can't even envision it, vision is antichaos—and yet everyone's vision is singular. Of course I could manage a degree of chaotic, unstructured imagery in my work. But only a degree. And I didn't like it. Second, an image that looked chaotic, utterly random, at first,

often didn't look random at all once I got familiar with it. I couldn't really make chaos. It was a relief to find that I wasn't interested in an absence of order. I was interested in freedom, which is different.

I was mistaken about chaos but it was a helpful mistake. Thinking about the way to get it—the sprawling, random quality of the world out there, outside of myself—into my painting helped me think about painting. I was suddenly conscious of my medium. It became one of my subjects.

One painter that I looked at through all of this was Agnes Martin. I was much more familiar with her work than with anyone else's. Around 1970, maybe '71, Douglas Crimp put on a show of her paintings in New York. The show was a hit. It inspired a lot of comment and brought Agnes's art out of hiding. She invited Douglas to visit her in New Mexico. When he arrived he felt shy, so he called me in New York and asked me to join him. Douglas knew how much I admired her work. I took the next plane, he met me at the airport with a rented car, and soon we were tremendously lost in the New Mexico desert. Now and then we'd run across a post office and ask for directions but we never seemed to get any closer to Agnes Martin. We began to have fantasies of starving. Finally we returned to one of our landmarks, the road at the bottom of the mountain where Agnes supposedly lives, and there she was in a pickup truck, waiting for us.

Looking for the Mountain came out of our stay with Agnes Martin. It was very dramatic. I don't know what Douglas thought, and he didn't know what I thought. We were on separate planets. I felt happy about the work, even though it was painted at the height of Minimalism and didn't really fit in. Enough people were curious about the painting to keep this from being a low period for me.

24

24. *Looking for the Mountain*. 1971. Oil, crayon, pencil, and ink on linen, 92⅜ x 75¼". Collection National Museum of American Art, Smithsonian Institution, Washington, D.C. Gift of Richard M. Hollander in honor of Jean S. Lighton

25

25. *The Way to New Jersey.* 1971. Oil, crayon, and
 pencil on canvas, 77¾ x 108". Collection Whitney
 Museum of American Art, New York. Gift of
 Philip Morris Incorporated

I have heard Painters acknowledge, though in that acknowledgment no degradation of themselves was intended, that they could do better without Nature than with her; or as they expressed it themselves, *that it only put them out*. A painter with such ideas and such habits, is indeed in a most hopeless state. *The art of seeing Nature*, or in other words, the art of using Models, is in reality the great object, the point to which all our studies are directed.

—Joshua Reynolds, "Discourse XII," 1784

CARTER RATCLIFF: Accepting the world's temporal flow, John Cage makes an accurate image of it. That makes him a suitable figure to preside over Pat Steir's effort to reach beyond the boundaries of her inward self. We could also make a persuasive claim on behalf of Agnes Martin. Her grids enfold space as powerfully as Cage's recordings embrace time. And, hovering in the background of Steir's attention, Jasper Johns's iconic forms helped her release her art from its strictly autobiographical fixations. Yet I've proposed the camera as the emblem of this second stage of her art, because photography helped her most when she wanted to escape her obsessive need for self-expression.

Subjectivity and objectivity are convenient words, but they don't allow much precision in the border regions where they meet. There are no absolute distinctions between inward and outward concerns of art. As Pat Steir points out, the Minimalists and Conceptualists told us much about themselves even when their art was at its most impersonal. And the most self-absorbed image must, to some degree, contribute to our picture of the world. Neither the intentions of artists nor the meanings of art can be simple. So we see a blend of representational and expressive impulses throughout Pat Steir's development. Wandering through Manhattan with a camera, she shifted the emphasis of her vision. With the pressure of her finger, the snap of the shutter, she turned more confidently outward.

I don't mean that her imagery took on a photographic tinge. It obviously did not. From the beginning, Steir has formed her images with a touch distinctively her own. But deeper than matters of style are questions of purpose. Whether formulated by Lord Byron or Ralph Waldo Emerson or an eighteenth-century rhapsodist of original genius like William Duff, the self-expression that first preoccupied Pat Steir is a comparatively new purpose for art.

26

26. *The Virgin's Dream*. 1972. Oil, crayon, and pencil on canvas, 108 x 72". Collection J. Patrick Lannon Foundation, Palm Beach, Florida

27. *Three Green Days*. 1972. Oil, crayon, pencil, and
ink on canvas, 72 x 108″. Collection Mr. and Mrs.
Anthony J. A. Bryan, Pittsburgh

28

28. *Cellar Door.* 1972. Oil, crayon, pencil, and ink on canvas, 72 x 108″. Collection Mr. and Mrs. Robert Kaye, New York

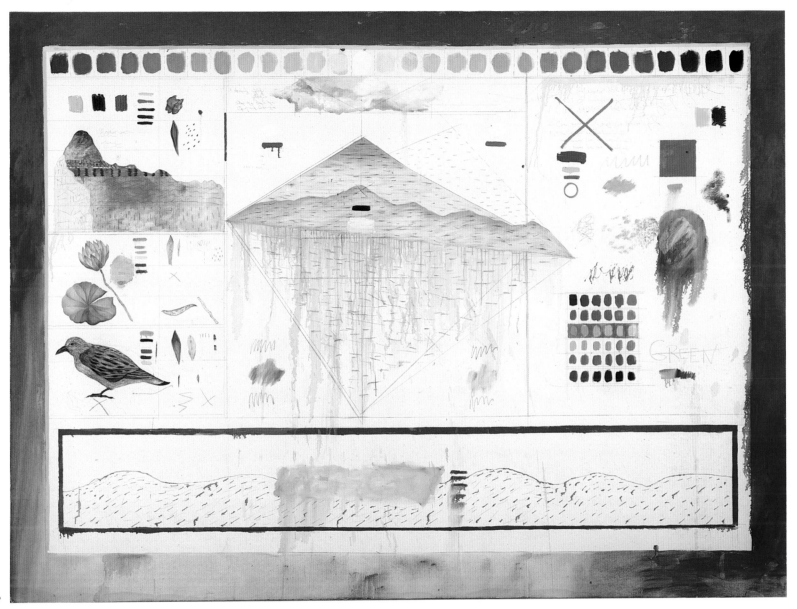

29

29. *Border Lord.* 1972. Oil and pencil on canvas, 72 x
108″. Collection Ponderosa Inc., Dayton, Ohio

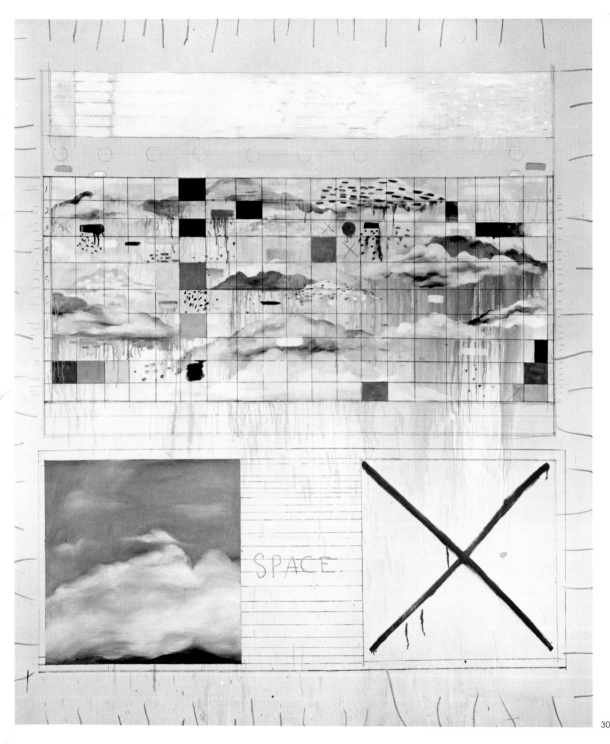

30. *The Four Directions of Time/No. 1: Standard Time*. 1972. Oil on canvas, 83 x 71". Whereabouts unknown

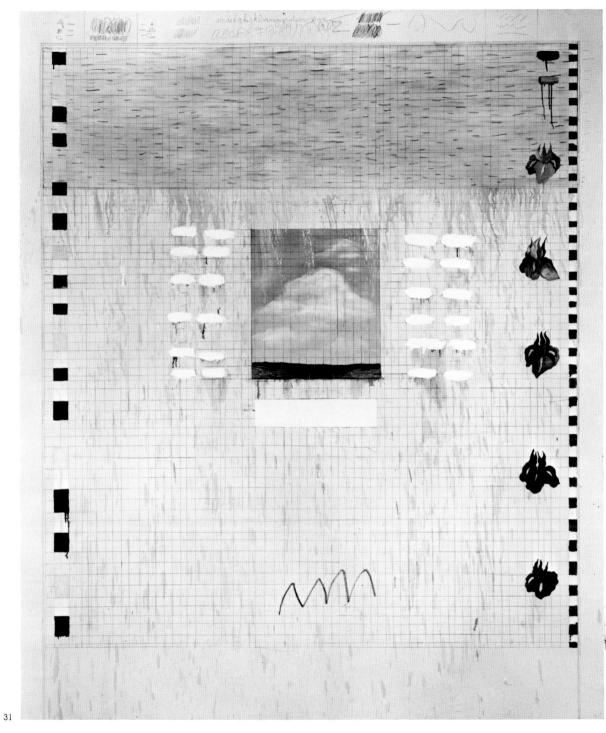

31. *The Four Directions of Time/No. 2: Entropy.* 1972.
Oil, pencil, and crayon on canvas, 83⅛ x 71¼".
Collection Dallas Museum of Fine Arts. Gift of
Shaindy Fenton

32. *The Answer for Anita and Leibniz.* 1972. Oil,
crayon, pencil, and ink on canvas, 94½ x 72".
Collection The Art Museum, Princeton University.
Gift of Leonard H. Bernheim, Jr.

33

33. *Veronica's Veil*. 1972. Oil on canvas, 8 x 6'.
Whereabouts unknown. Courtesy The Harcus
Gallery, Boston, and John C. Stoller and
Company, Minneapolis

34. *Night Flight over the Desert.* 1972. Oil on canvas,
108 x 84″. Whereabouts unknown

35. *Circadia.* 1973. Oil, crayon, and pencil on
 canvas, 84 x 84". Courtesy Wendy S. Hoff,
 American Art, New York

36. *Or.* 1973. Oil on canvas, 72 x 191½". Collection the artist

Far more ancient—indeed, Aristotelian in its most powerful formulations—is mimesis, the imitation of nature. Mimetic art gives the self second place to the world.

After centuries of scholarship it remains difficult to say what Aristotle or any early band of Aristotelians meant by mimesis. It is hard enough to see what Alexander Pope is getting at, in his *Essay on Criticism* (1711), when he says that "Unerring Nature" is "the Source, and End, and Test of Art." I mean, if the source of a work of art is the same "Nature" that provides it with its goal, how are we to tell the difference between art and the world? Yet that is not a serious difficulty. No one long mistakes a painting for an open window. Like most proponents of art as a picture of the world, Pope makes his claims too specific. Or they are so general they claim nothing at all. Of course, he has brilliant defenses against objections like these. Joshua Reynolds has less to say if we ask why some aspects of nature are suitable models for art and some are not. But there is no need to ponder the puzzles that have gathered around the idea of mimesis during the last twenty centuries. It is enough to note that the idea is still alive—Jasper Johns: "Watch the imitation of the shape of the body" (1965)—and that it helped guide Pat Steir out of her labyrinth of self-expression.

PAT STEIR: I have always had the difficulty of supposing that my personal symbols are common to everyone. I still do, even though I've become extremely conscious in recent years that everyone's point of view is different, that different artists' styles indicate very different attitudes, and symbols tend to be completely idiosyncratic. But I was only half aware of all that in those days.

The Four Directions of Time/No. 1: Standard Time is really a New Mexico painting. I got completely involved with the landscape—the feeling of isolation in that space. The painting is about New Mexico but it's also about the differences between the realism of the sky and the Xs that stand for space. And the varieties of paint. First the pigment is all white, then foggy, then color appears. Different kinds of imagery cause the eye to see differently. Reality is in that sort of difference. And there is an underlying similarity between these various visions, these different realities. So the differences are temporary. They're contingent, and that seems especially clear in an immense space like the New Mexico desert. In spaces like that I feel very temporary and small.

The Night Chant Series is also from New Mexico. They are about the ceremonies the Navajos use to cure schizophrenia. Naming the ailment, the shaman cures it. That is what interested me, that a name could be a cure. I didn't attend the ceremony but I could hear it from far away. It lasts all night. My painting begins with the peacefulness of that memory. I was completely alone. I could hear the drum and my heart and a hissing—white noise, just the presence of my blood, my mind. The mind alive to itself. You don't make a distinction between what is imaginary and what is real. At dawn, the schizophrenia is cured.

The grid and all of painting's systems of naming took on the significance that ceremony had for me. A painted flower was to be seen as a painted flower. And more touching than if it had been real. Everything was what it was, and yet able to find an affinity with other things, images, marks. For me the grid was no longer just spatial. It became a place in time as well. I obviously got that from Agnes Martin. But my inventory of the world was beginning to produce unities. So I use a typewriter whenever I have something to think about analytically because a pencil turns everything into art. As soon as I take up a pencil I'm making a drawing, even if the marks I make form words.

Now that I've become so conscious of the various conventions we use, verbal and visual and so on, I'm always aware of the difference between writing something by hand and drawing something. Yet the two activities still seem very, very close to each other. Intertwined, almost identical. In this earlier period when I was seeing all lines as figures, whether they formed letters or pictures, I often decorated words. So it is sometimes difficult to tell the verbal from the visual even if you insist on the difference between language and pictures.

37

37. *Night Chant Series, No. 1: Beauty Way for J. B.*
1973. Oil on canvas, 72 x 72". Collection the artist

38. *Night Chant Series, No. 2: Epiphyte for G. B.*
1973. Oil, crayon, and pencil on canvas, 84 x 84".
Collection Barbara and Alvin Krakow, Boston

39. *Night Chant Series, No. 3: Dawn.* 1973. Oil,
crayon, and pencil on canvas, 84 x 84".
Collection Mr. and Mrs. S. I. Newhouse, Jr.,
New York

I kept thinking that the line is an image—an image of a figure. Or it might not be a figure, just a collection of lines. It depended on what kind of illusion I was making. In some of the works from this period, I describe colors—not a concrete description, more an evocative, poetic description: "Yellow sun, blue sky, red, red, lazy head, black bird sitting." Like children's poems. The kind of description that builds up into an image.

That writing on the canvas came out of thinking about other artists. This wasn't the art-historical speculation that appeared not so long afterwards. I was thinking about contemporaries, the Minimalists. That's who my friends were, that's who was around for me. By then—it was the early seventies—they weren't really making pictures. Most of them were using words. So did I. It had been impossible for me to make chaos. This was a relief until I began to see iconic meanings in everything. Even the sparest pencil marks looked like landscapes to me. It was the opposite of chaos. Images proliferated everywhere in my work.

This was when I started writing in the space around the central squares in my paintings. So my attempt to achieve a random, chaotic flow of images had led to a flood of imagery with an overflow of meaning. So I wanted to abandon the image. It's as if that flood from my own unconscious was oppressive. I wanted to bring it under some kind of control, so I began to work my way toward basics—the elements of art.

One way to bring the image flood under control would have been to focus it on figurative art in the usual sense—pictures of people. I had learned that I can't stay away from images of the figure. Why not just become a figurative painter? On the other hand, why bother, now that we have video and film? Why should I make the effort to tell a story that a video artist or a filmmaker can tell much more efficiently? So I couldn't abandon the figure but I couldn't deal with it either. Not directly. I'm interested only in abstract painting.

I wanted to see what made what. What set limits to what. It was all vague, though I was fairly certain it had something to do with the edges of a canvas or a drawing—what contained what. I tried to use the image as a frame, and to put writing in the center as a subject. I did some family portraits, mostly words and numbers. Then came a series on brown wrapping paper that I found when I was in Sweden. It's called Stockholm Brown. Each of the works is small, about ten inches square. When there was writing I usually crossed it out. This series follows the life story of a line. I would fill up the surface, take the image away. Writing would form a picture, a picture works as a kind of writing.

In many of the paintings and drawings from this time, I surrounded the central image with variations on its own forms. So the image encloses itself in a way. I may have been presenting myself again, but secretly: the source of my imagery wrapped in my imagery, and just as self-absorbed as ever. Or maybe not. I don't know. I'm not sure. One of my paintings from this period starts with an empty square on layout paper, paper with a grid of light blue lines. There is another poem in one of them: "I don't no nothing." Often these paintings say something and then that something is crossed out. Another one of these works says, "Remember me, remember me." I was thinking about the essence of art. I thought it must be "Remember me." But not that early impulse just to present myself: "Here I am." Instead I was placing myself in the world, however tenuously. And I was acknowledging others, viewers who would or would not remember, and even hinting at time—not just the flow of the moment, the present that was producing my investigation of the world, but a much longer span. A time that could include forgetting. Time that had to be redeemed by history. But I wasn't thinking much about history at this point. Only later, when it became a subject. Or the subject for me.

40. *Breadfruit.* 1973. Oil, crayon, and pencil on
canvas, 84 x 84". Collection Martin Melzer,
New York

Breadfruit, which I made in 1973, is another one of my first paintings. Again, I was beginning at the beginning. This is a big canvas, seven by seven feet, with a lot of painting. Just paint. I was getting to the elements of painting, the painting of a painting as literature: naming itself. This is it. I found it. Then breaking the image into its constituent parts—line, texture, color. Learning how to mix those parts. The flower is a made-up flower.

Not all the flowers from this time were invented. Sometimes I painted recognizable irises. My first name is really Iris so an image of that flower is always a self-portrait. I still had the feeling that I had to put myself into the painting. That stopped with the Breadfruit painting. Until then I thought doing the painting was not enough. I had to be in it somehow, a ghost of that self-expressive self that I had put at the center of my very first paintings. After the Breadfruit painting I wanted to destroy images as symbols. To make the image a symbol for a symbol. I had to act it out—make the image and cross it out. I painted a rose and then painted an X over it. That's how I did Nothing: no imagery, but at the same time endless imagery. Every nuance of paint texture worked as an image. After I worked things out with Jasper Johns, Robert Ryman became a problem for me. What to do after somebody has painted a painting of painting?

In the mid-1970s I began to analyze the typical mark of several artists, including Van Gogh, Goya, De Kooning, Rembrandt, Jackson Pollock. Because their works were history, I thought of my paintings about them as figurative. I thought the literary and historical aspects made them figuration, even though there was no figure or image in them.

There was a figurative exhibition that I wanted to be included in. I couldn't understand why I wasn't included, so I called up and asked. I was told, "You don't make figures any more." I said, "Yes I do, yes I do." I insisted that the words in my paintings are figures. The "I" in the painting is a picture of me. Until then I thought everyone understood this. For the first time I realized that my way of seeing art—my own art, especially—

could be completely different from the way other people see it. I was shocked. I had seen my writing as a kind of figurative drawing. Now I had to readjust my art, my whole life, to what I had just found out: that no one else saw the writing as I did.

I still think the "I" on the canvas is a figure, but I began to take into account the possibility that not everyone would agree. At this point I started to become much more aware of other artists and of art history in general. I had been showing my work for five years. I had found an audience, an appreciative response. But in a way I hadn't realized that there was a world beyond the borders of my own art. My audience had seemed completely natural to me, just an extension of myself. Of course they liked my work. They were just like me. But this experience had suddenly put me in a position where I had to admit that the audience was not just like me. The audience has its own way of seeing things, maybe an infinite variety of ways to look at art. Nothing seemed quite so natural any more. That is when I began to be interested in style, the arbitrary quality of it, and I was soon involved in the question of how style evolves.

The Burial Mound series of 1974 kept me in the present, still carrying out my inventory of the world. Only now I was concentrating on the means of picturing the world. These works continue directly from Breadfruit. They are about the elements of my art. By now I had begun to cover up my writing almost completely. I had collected a mental toybox full of almost entirely visual forms. I had been moving through the world, picturing it. Now I would picture picturing. I tried to reveal myself through my art and I had gotten my art to reveal itself. Right after that, an immense shift occurred. My art changed again. I thought I had discovered, say, line. But not long after the Burial Mound series I made a painting with another artist's line. Not really, of course, but a line in another artist's style. Not my own. Or not completely my own. I had been ranging through the present. Now I plunged into history.

41

41. *Black.* 1973. Oil and pencil on canvas, 72 x 132″.
Collection Steven D. Robinson, Miami

42. *Line Lima*. 1973. Oil, crayon, and pencil on
canvas, 84 x 84″. Collection Whitney Museum of
American Art, New York. Anonymous gift, 1974

43

43. *Deviations and Variations.* 1973. Oil and pencil
on canvas, 72 x 72". Collection Martin Melzer,
New York

44

44. *As I Am Forgotten.* 1974. Oil on canvas, 84 x 84".
Collection Honolulu Academy of Arts. Purchased
with funds from the Shidler Family Foundation
and the Museum Acquisitions Fund, 1985.
Courtesy Fuller-Goldeen Gallery, San Francisco

45. *Word Unspoken*. 1974. Oil and pencil on canvas,
72 x 72". Private collection, Chicago

46. *L.A. Sunshine Surprise.* 1974. Oil on canvas, 42 x 84¼". Collection Dr. Wilford Grover, Pompano Beach, Florida

47. *Nothing.* 1974. Oil on canvas, 42¼ x 84″. Private collection

48. *Nabaye Tabastan for L., T., & R.* 1974. Oil on
canvas, 84 x 84". Collection The Museum of
Modern Art, New York

CARTER RATCLIFF: I suggested that photography guided Pat Steir's art toward a variety of mimesis. Hers was an Aristotelian camera, drawing her out of herself and into the world. "Aristotelian camera" is an anachronistic phrase, deliberately so. I use it to suggest the long, labyrinthine path the mimetic impulse has taken over the past two thousand years. We who find photos so intelligible have forgotten much about Aristotle, who knew nothing of cameras. Nonetheless, Aristotle lurks in the background of our present, though it's doubtful that he or Pliny or even a nineteenth-century academic would recognize Steir's art as a variety of mimesis. Yet her schematic birds and quasi-abstract flowers, her repertory of private map symbols and handwritten words, offer pictures of the world. They present us with an imitation of nature, of real and visible objects. These images also touch on ideal things. Plato lurks in the background too. He isn't highly visible. None of these ancient figures is. Nonetheless their theories, endlessly modified, form part of the fabric of our culture—its present texture, of which we are largely unconscious.

There is something autobiographical, reportorial, Aristotelian, about the elements of *Breadfruit* and the *Burial Mound* series. Yet Steir treated these forms as if they were not hers alone but timeless, unchanging, utterly basic—like the "Ideas" that inhabit Plato's heaven of absolute realities. So the mimetic detail of her art collides with its generalized clarity, its yearning for the transcendent state that Giovanni Pietro Bellori, the seventeenth-century Neo-Platonist, grants only to the primary forms that God established when he created the universe. Yet Bellori expects the artist to achieve what we would call a high degree of empirical—or Aristotelian—truth. The threads of one tradition are often impossible to extricate from the knots created by another.

Modernists, like Romantics before them, tend to treat the heritage of Aristotle as their private property. For the past two centuries the mimetic inventory of the world has been inclined to turn into the artist's relentless self-scrutiny. Poets of whom Shelley is a prime example, almost a stereotype, hold up the mirror of art to their own faces, not to nature. Or art can mirror itself. Pat Steir shares with Jasper Johns and many other artists of our time the willful desire to invent an idiosyncratic mimesis—not so much a way to picture the outward world or the inward, as a personal style's reflection on its own singularity.

But—to return to Shelley for a moment—he claimed for his art, for all true art, the power to present "the very image of life in its eternal truth," as the Neo-Platonic heritage demands. Imagination's purpose is to express the world's "indestructible order." Later Barnett Newman spoke of "absolute emotions" in place of absolute forms. And Pat Steir sensed absolutes in the naming rituals of the Navajos. Having heard the distant ceremony, if not the names, she went on to the discovery of forms that served, in her art, as the elements—the fundamental ideas—of art itself. Those elements of art are her metonyms for the elements—the eternal "Ideas"—of a world indubitably real.

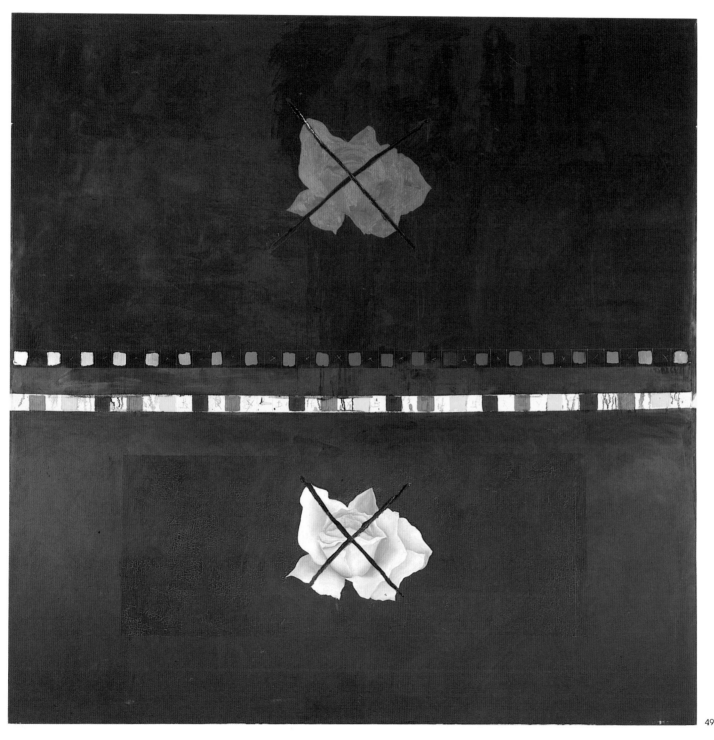

49

49. *Word Unheard.* 1974. Oil on canvas, 84 x 84".
Collection Albright-Knox Art Gallery, Buffalo.
Promised Gift of Mr. and Mrs. Armand J.
Castellani

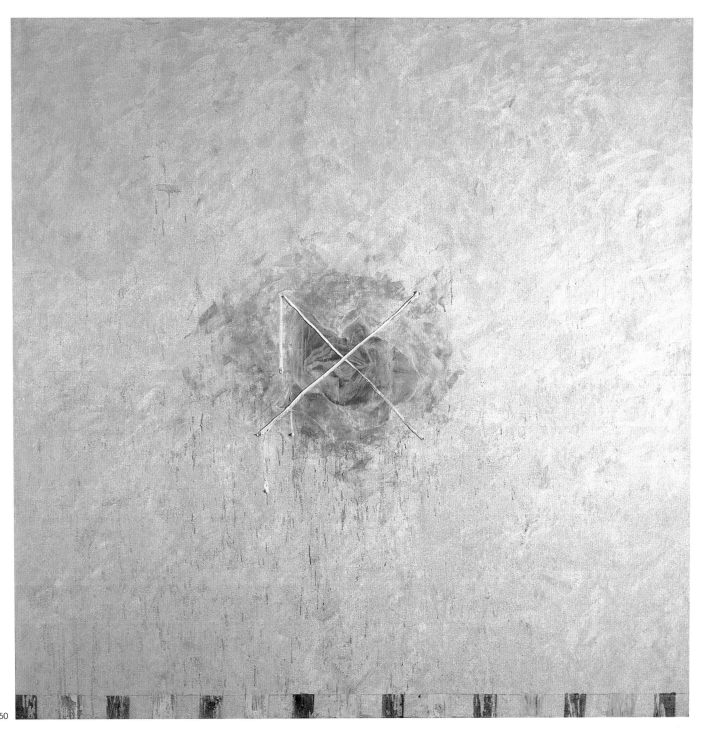

50. *Moment.* 1974. Silverpowder, damar varnish,
 and linseed oil on primed canvas, 84 x 84".
 Collection Ann Walker, Sun Valley, Idaho

PAT STEIR: I had begun to show my work in Europe. There was a reason to draw instead of paint: drawings are more portable. Anyway, being in countries where different languages are spoken produced a strange feeling. I began to feel the impact of language on thought and thought on language—how different languages imply different ways of seeing and being. That thought carried over to my art. I saw that artists chose abstract or figurative images to suggest the different ways we see under different circumstances. The nearer you are to the thing you're painting—or seeing—the more abstract it would get. Eventually these concerns led to a very deep change in my art. Instead of investigating myself, for example, or the elements of my style, I made subject matter of the immense disparities between different styles, between different historical periods. But that didn't happen right away.

In those days I was interested in Leibniz on one hand and Darwin on the other. Leibniz tried to think his way to the best of all possible worlds, to get to that sort of absolute through logic—out of himself. I found his efforts very touching. I was more interested in Darwin than in his theories. He had five notebooks which he kept concurrently. There was an order to the record of his thoughts but only he knew it. I liked the complexity of it. I was drawn to systems with complex structures— Lévi-Strauss's structuralism; also Freudian thought, which seemed to lead much further than Jungian myth. Painting was the medium that brought everything together for me. I was looking for a form that did away with the difference between a verbal and a visual image, and erased other boundaries too. Only later did painting begin to seem like a thing in itself, something specific. For years it was more like an investigative tool.

Until 1975 I always thought I was involved with literature. For me, painting was a way to get at thought processes. I wasn't interested in the history of the medium. I saw art history as a blank. I knew it was there but history didn't have a historical meaning for me, so to speak. Everything I cared about was in the present I was moving through, trying to deal with. I was exerting a sense of self, extending myself into the world through

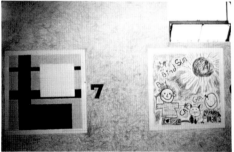

51–53. Installation, children's art school, Birmingham, Alabama. 1978

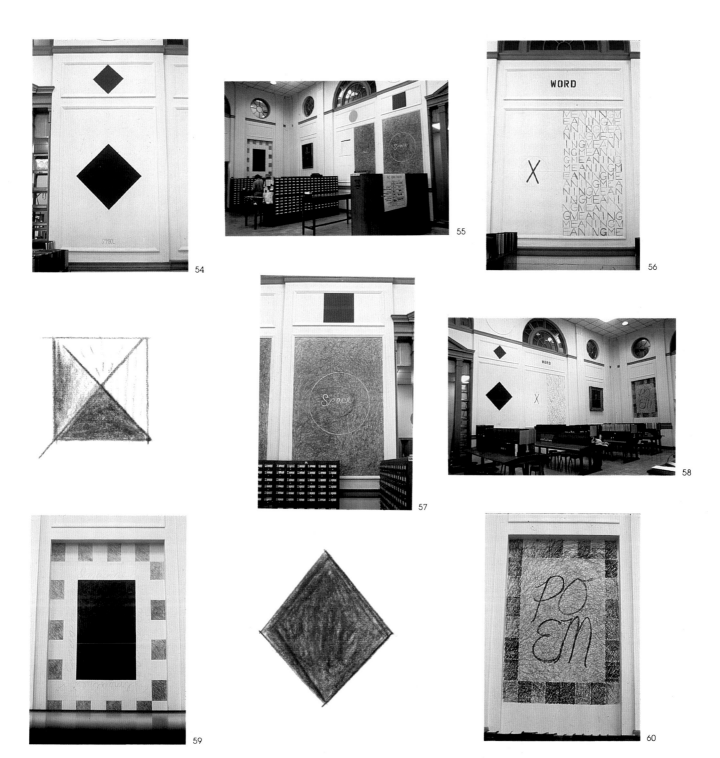

54–60. Installation, Louisville, Kentucky. 1978

my art and struggling to come to some sort of understanding of the universe at the same time. My visual mediums were like research methods, and art was an insane kind of research. I thought of myself as a writer. Then I realized that I was a painter. Next it occurred to me that I wasn't alone in this. I was part of a history.

Before, when I thought of art as research, my research topic was always myself. I got at it in a variety of ways, from musical to philosophical, semiological, but that subject always remained, even when I thought I was conducting a totally impersonal investigation into the nature of paint. By 1975 I had enough material, I had absorbed enough, to say, "Okay, I'm going to be interested in painting." I had seen an early self-portrait by Rembrandt. There is one surprising thing about it. I almost couldn't believe my eyes. Rembrandt's face is dark, barely painted. His hair, which was very kinky, is silhouetted against the sunlight. The curls are scribbles. It took my breath away because—there it was. Everything we call contemporary. Yet it belonged completely to its own moment. That is what gave it its humanity, its insight. I realized that each generation has to go through the same crisis of not knowing where it is, submerged in a present that feels boundless, maybe chaotic, then finding its way out to the point where we are able to see where we stand historically. Where we stand in relation to everyone else and other times.

So I stopped using art as research into other subjects. Art became my subject. This change made me much more self-conscious. I had been immersed in questions of my own existence before. Now I saw myself, my art, in relation to other artists, the past, the culture. I made a subject of the myths that society develops from the illusions of art. But since all this came out of a sudden leap into a self-conscious way of doing art, that self-consciousness is also part of my subject matter. And of course that means that my art is still about me. It is me, though I have changed very deeply. And painting is still my vehicle for being. I still examine the world through painting. But now it is the world, being, in the light of a sense of history, not sheer existence immersed in an endless, unconscious present.

61

62

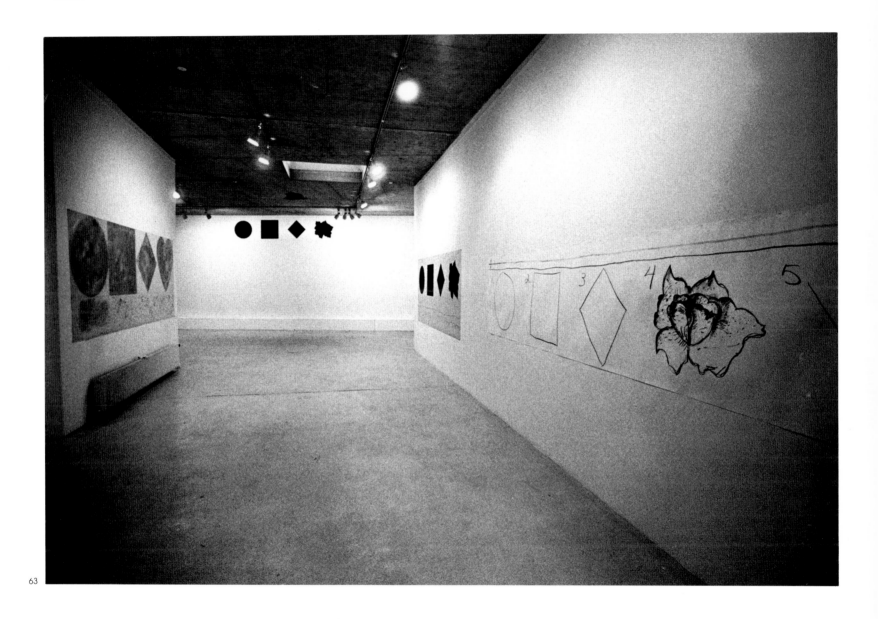

63

61–63. Installation, Galerie Farideh Cadot, Paris,
April 1975

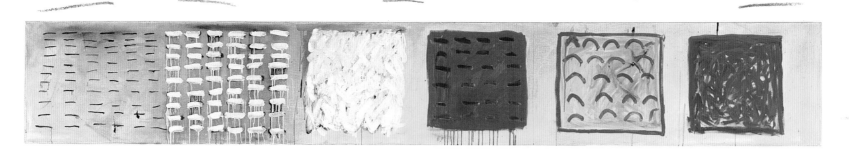

64

64. *Long Chart, Large Chart.* 1977–78. Oil on
canvas, 4 panels: 17 x 114″, 17 x 103″, 13½ x 95″,
13½ x 93¼″. The Phillips Collection, Washington, D.C.

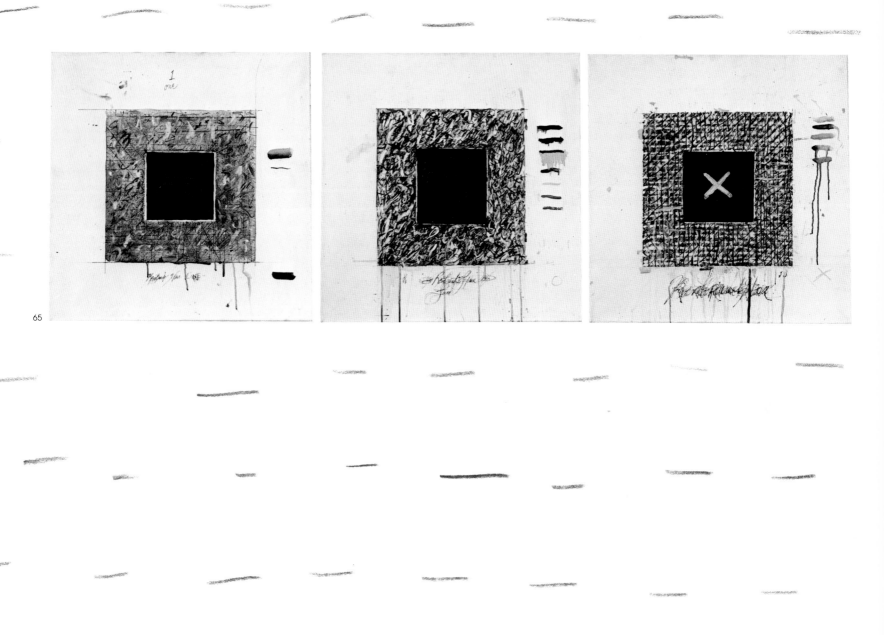

65

65. *Rembrandt's Hairline No. 1.* 1978. Oil on canvas, 21½ x 65". Collection Jean Paul Jungo, Morges, Switzerland

66. *Beautiful Painting.* 1977–78. Oil on canvas,
24 x 120″. Collection Vera G. List, New York

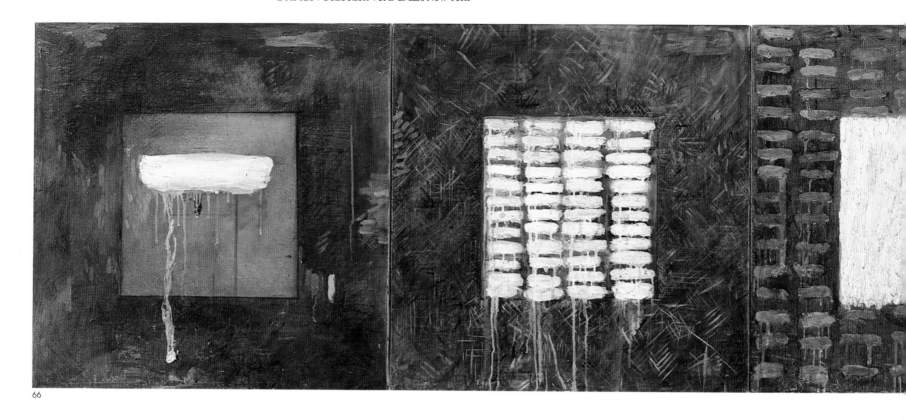

66

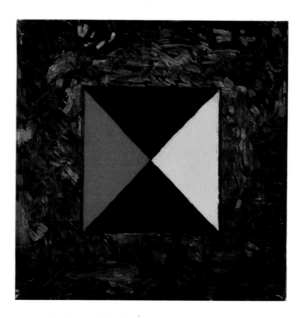

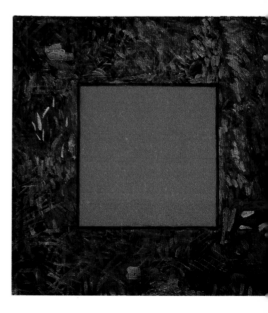

67

67. *Beautiful Painting with Color.* 1978. Oil on
canvas, 30 x 180″. Collection The Museum of
Modern Art, New York

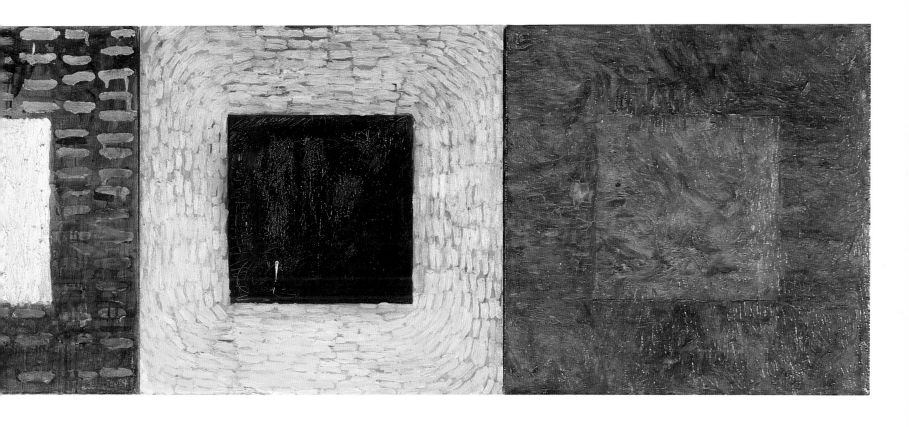

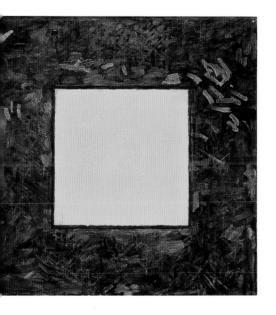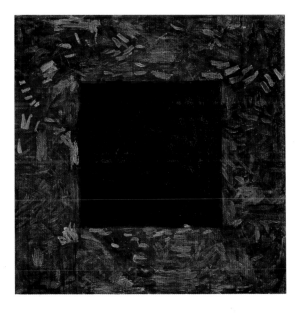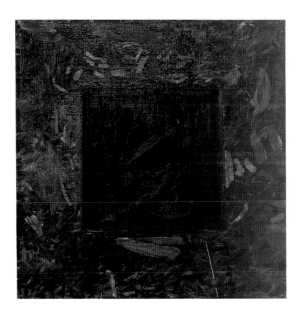

Besides Rembrandt, Manet was crucial. So was Courbet. Once, when I wanted to paint some water paintings, I looked at Courbet's seascapes. I realized that his images are just big blobs on canvas. If you look at them close up, they're totally abstract. Then you move back and see an image. Other painters did it differently at different periods, or in different milieus. Manet is obviously a strong personality, but his painting is about seeing, not about being. And I began to notice that there was a history of seeing, so to speak, and the history of painting recorded it.

In 1976 I did a project in an art school in Birmingham, Alabama. There were 5,000 square feet of wall space to be covered, and we did it in a single day. I gave the children problems to solve, problems that came out of the work I was doing then. I'd say, "Draw an image the way a Constructivist would do it." They would ask me what I meant by "Constructivist." I'd show them some reproductions and they'd get to work. I had them draw in the most primitive way they knew how, draw with numbers, draw as a child would draw, and so on. The miracle was that the results looked as if I had done them with my own hands. It was startling.

By now I was acutely conscious of art history. I ought to stress that I had studied it in school. I couldn't avoid it. But I didn't really know what history is. I think history courses for artists encourage that view of the past—not as the past, really, but as a particularly interesting portion of the present. I know I was inclined to look at history as just a set of possibilities I could draw on whenever I needed something. But I hadn't really worked through history. I didn't understand what it meant for the past to be past, over and done with, and so I had no idea how isolated in a particular time a particular artist can be.

By the end of the seventies, I had made paintings that referred to Sol LeWitt, to Jackson Pollock, to other artists. When I had done several canvases after Willem de Kooning, I realized I was dealing with the image less in terms of language and more in terms of what you see. Long Chart, Large Chart is an inventory of marks, but they are fully painted—painted in full. Then came Rembrandt's Hairline. I consider this the first painting I ever did. Literally speaking, I had been a painter for years when I made this work. I had been exhibiting and

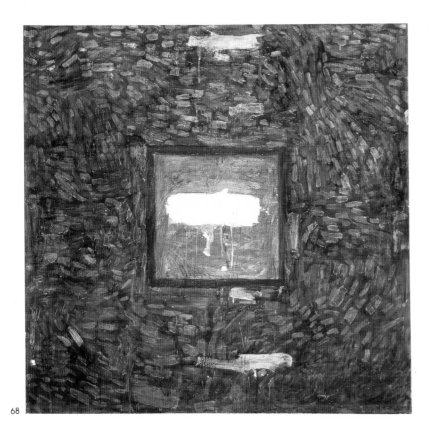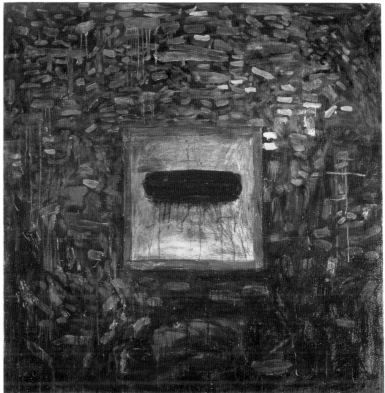

68

68. *Van Gogh/Goya.* 1978. Oil on canvas, 48 x 96".
Collection Sydney and Frances Lewis
Foundation, Richmond, Virginia

selling my work. Still, this is the first work of mine that counts as a painting the way a canvas from another century does. This is the first of my paintings to join with art history.

My art education really only started after I decided to work through the entire history for myself. The work I did before 1975 is very touching to me now. And I'm touched by people who like that work. It seems to come from somewhere outside of history. It's a kind of groping for meaning at a time when I was completely isolated, inside of myself, not connected to history.

In part, I found my way into history by traveling. My trip with Douglas to see Agnes Martin had been like a journey to a primal source, an origin of form and of spirit outside of history. But with Beautiful American Painting and Beautiful Italian Painting I deliberately began to make use of different traditions in ways that emphasize their differences—that use stylistic differences to point to differences in culture and history. That becomes part of my subject matter. Also, the stages that lead from one historical period to the next.

I wasn't interested in making my art a visual analogue to art history—in other words, I didn't want to illustrate scholarly findings—but I did want to evolve imagery that would give my sense of the way painted images have evolved. Painting had been a means to an end, an investigatory tool. Now I was investigating the history of painting, and doing it in the only possible way: by painting real paintings, works of art that belong to the history of painting as a medium.

I developed a whole dictionary of forms—lines, cubes, spheres—and other figurative images, angels that I got from Giotto, for example. Numbers and the alphabet. The simplest form generated volumetric form. Then the illusion of volumes in space evolves into myth. I made three-part paintings that showed this progression, and I composed a lecture to go with them. I felt I had everything, that nothing was left uncovered.

I had gone from the simplest pictorial elements to the most complex. Along the way I had framed these images with variants on themselves, which changed them from images into signs for images. Then I added signs for various national styles—Dutch, Italian, American. Now with my lecture, I had not only done everything. I had explained. It was all under control. Then I thought, "What to do?"

This took place during a period of about five years. I had been living in Europe most of this time, out of the American art world, bringing my work to certain conclusions. Now I had done it. It was like adding up numbers until you get them right. And being happy with yourself that you're smart enough to do it. I suppose my work was still extremely Conceptual. But its concepts were no longer so entangled with language. I still don't think of myself as a painter. Who's interested in painting? I'm not. I am, but I'm not. Yet I had arrived at the point where I could see the beauty in painting. That was a very recent development—about 1977, I think. I began to be able to see what was remarkable in a great painting. After seeing a major canvas, one I thought was really powerful, I would see everything in its terms for the rest of the day. So my sense of painting had become completely visual for the first time. And I was able to see—literally, to see—how a painting can define one's vision.

But I hadn't really achieved a historical vision. Not quite yet. I had managed to absorb my interest in history into my research. I had dehistoricized it, so to speak, and that led to the satisfaction of feeling that everything was worked out. In a way, I was right. I had added up the column of numbers correctly. My visual lecture on "Form, Illusion, and Myth" accounted for everything in my new paintings, and my new paintings accounted for everything crucial to the medium. But of course it wasn't quite like that.

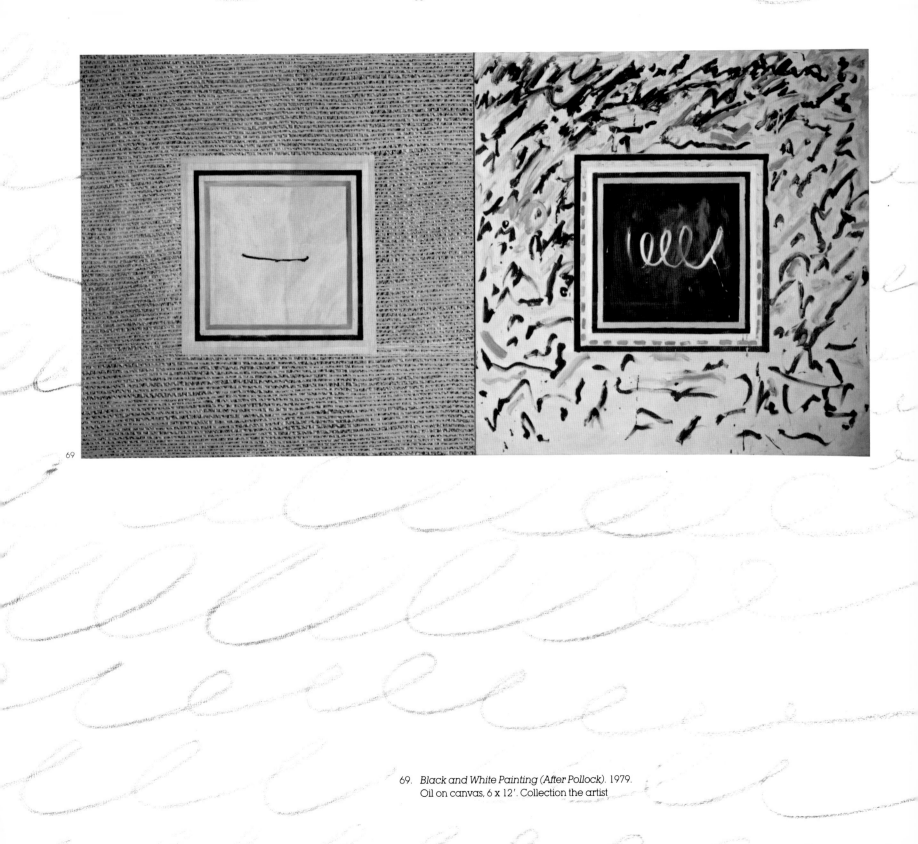

69. *Black and White Painting (After Pollock)*. 1979.
Oil on canvas, 6 x 12′. Collection the artist

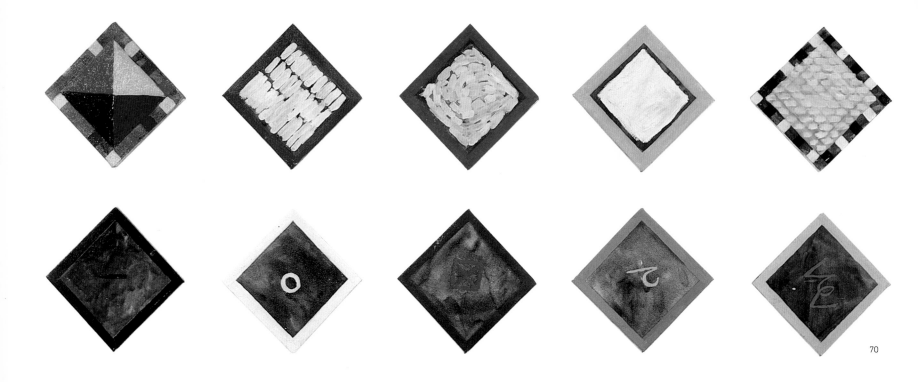

70. *Diamond Series*. 1978. Oil on canvas, 10 panels,
 each 8 x 8″. Private collection
71. *Rembrandt's Hairline No. 2*. 1979. Oil on canvas,
 21½ x 65″. Collection Musée d'Art et d'Archéologie,
 Toulon, France

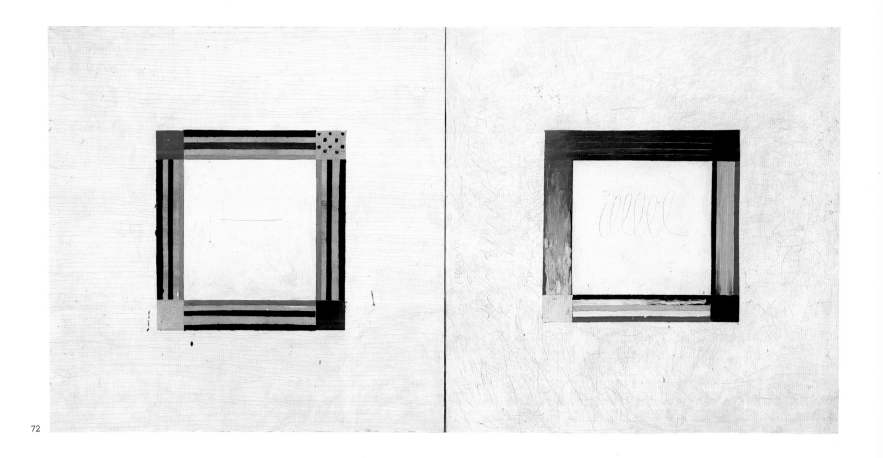

72

72. *White Painting with Colored Bands.* 1979. Oil on
canvas, 6 x 12′. Collection American Telephone
and Telegraph Co., Boston

73

74

73. *American Painting (Homage to de Kooning)*.
 1979. Oil on canvas, 72 x 144″. Private collection,
 Colts Neck, New Jersey
74. *Untitled*. 1980. Oil on canvas, 72 x 144″.
 Collection Jean Paul Jungo, Morges, Switzerland

75

75. *Line*. 1980. Oil on canvas, 48 x 48". Private
collection, Washington, D.C.

76

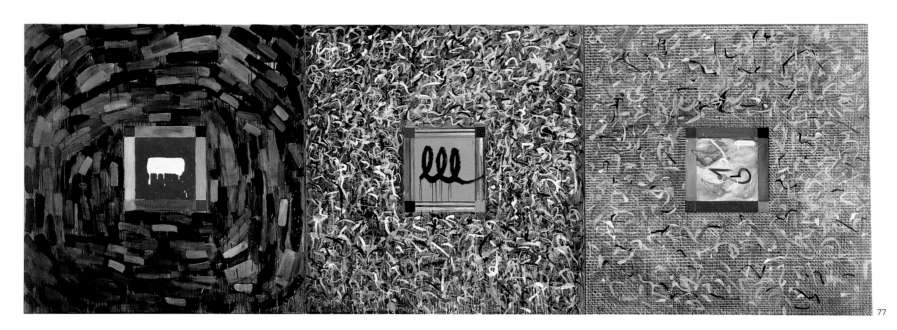

77

76. *Beautiful American Painting.* 1980. Oil on
 canvas, 5 x 15'. Collection the artist
77. *Beautiful Italian Painting.* 1980. Oil on canvas,
 3 panels, each 63 x 63". Collection Edna S.
 Beron, New Jersey

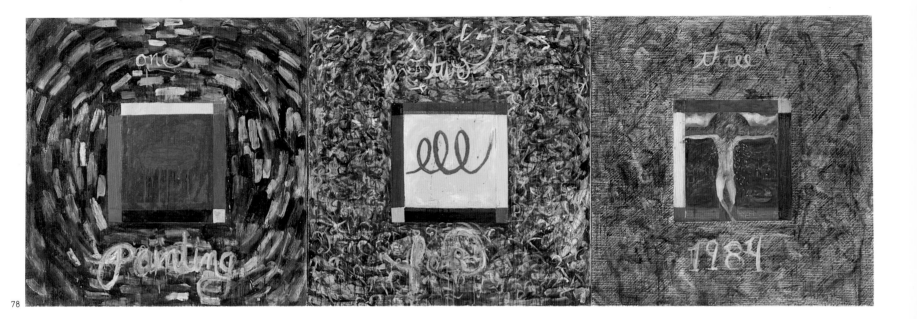

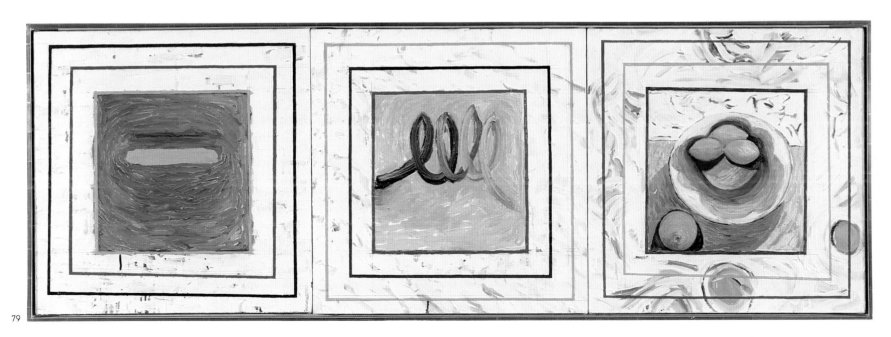

78. *Painting for 1984.* 1981. Oil on canvas, 42 x 126".
Collection the artist
79. *Triptych with Still Life.* 1981. Oil on canvas,
30 x 90". Private collection, New York

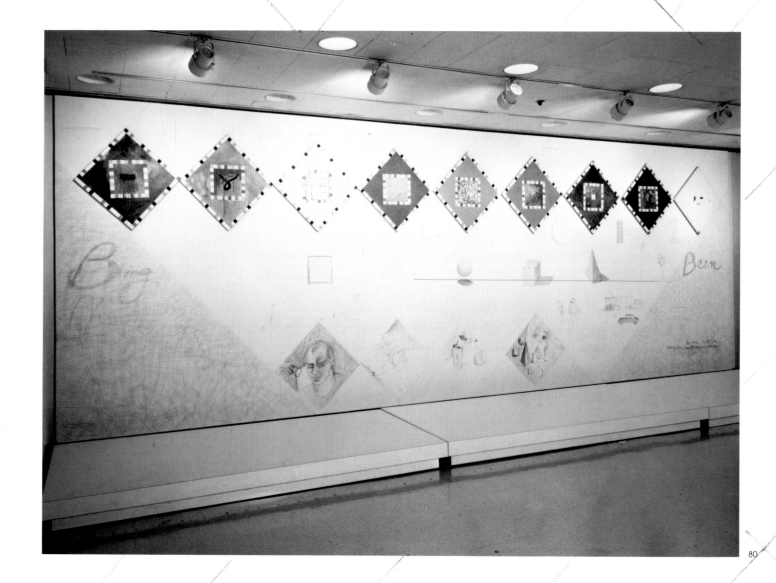

80. *Lima Being (Being/Been)*. 1980. Oil on canvas,
with wall drawing, 9 panels, each 23¾ x 23¾".
Collection The Chase Manhattan Bank,
New York

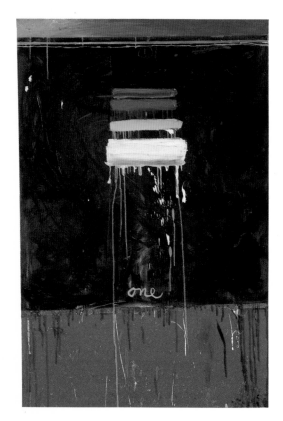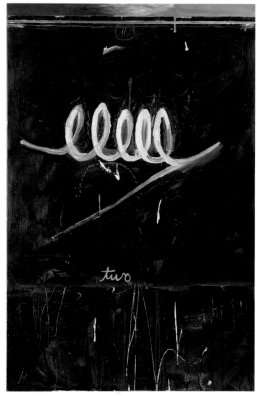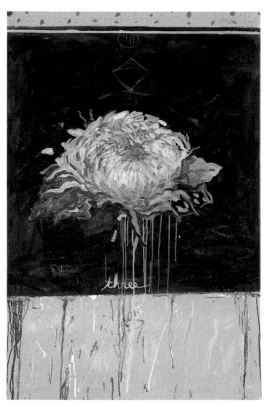

81

81. *Beautiful Chinese Painting.* 1980–81. Oil on
canvas, 19¾ x 32″. Collection Jean Paul Jungo,
Morges, Switzerland

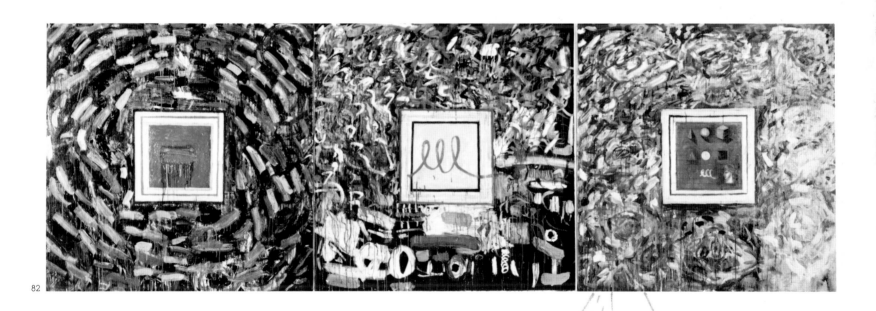

82

82. *Il Sogno di Botticelli.* 1981. Oil on canvas, 6 x 18'.
Courtesy Michael Klein, Inc., New York

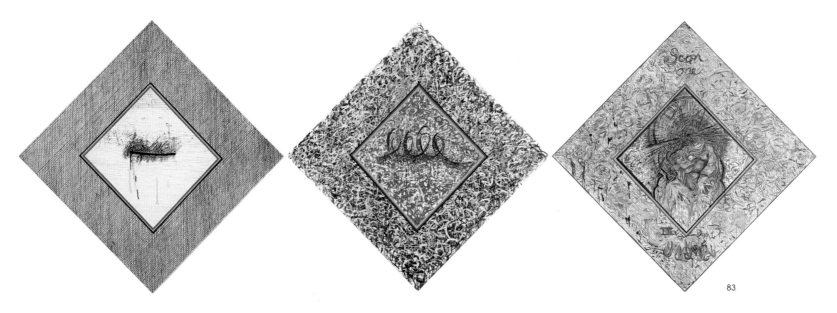

83. *Icon One: The Mother.* 1981. Oil on canvas,
3 panels, each 48 x 48″. Courtesy Galerie Eric
Franck, Geneva

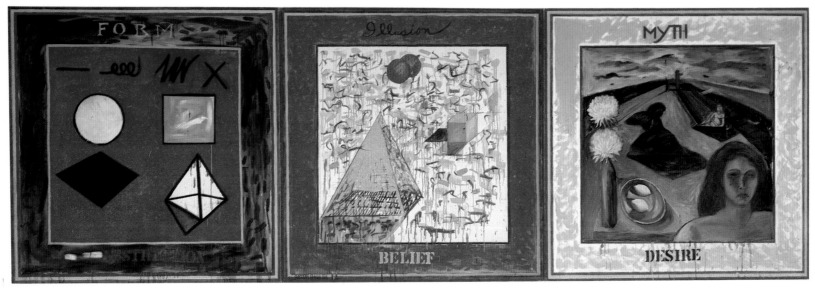

84. *Abstraction, Belief, Desire.* 1981. Oil on canvas,
5 x 15′. Collection The Prudential Insurance
Company of America, Newark, New Jersey

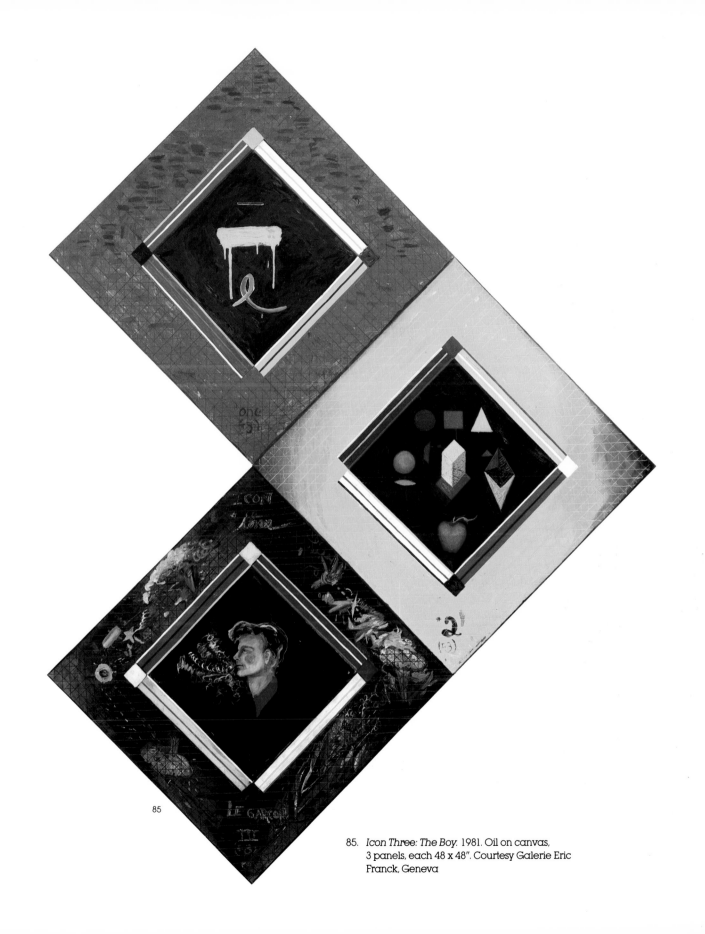

85. *Icon Three: The Boy.* 1981. Oil on canvas,
3 panels, each 48 x 48". Courtesy Galerie Eric
Franck, Geneva

Once you get a sense of history, you find that it is impossible to settle into a timeless moment and be satisfied that everything is completely under control. There is no timeless clarity, when you think you—or your art—has achieved it. I couldn't help becoming more and more involved in the question of how art related to the rest of society, how art-historical developments affect the way things look and what they mean. I got interested in quotation. I didn't just want an image or even a conceptually precise sign for an image. I wanted to include signs that would indicate the origin of the image. I wanted my paintings to have—or even be about—an awareness of origins, of history.

I started to use, say, a Futurist image, a Cubist image, a fifteenth-century image. And my concern isn't simply to point to the evolution of style or the different modes of vision implied by different styles of painting. I'm interested in the power of a style, a mode of seeing, to attach itself to larger meanings, to be the vehicle for myth. When I began to paint three-part sequences of the same motif in three distinct manners, I would say that the progression was from a realistic to an abstract image. But those distinctions are arbitrary, as everyone knows. Usually people claim that all images are abstract, even the ones we call realistic. I think that it's the other way around. All images are realistic. An abstraction, so-called, is a straightforwardly rendered view of something from very close—so close that we lose sight of its familiar outlines. We watch them disappear.

A couple of years ago I was in a panel discussion with some other people from the art world, artists and curators. When it was my turn to speak, I said that there are three kinds of artists now. The first are the political mythmakers, people like Vito Acconci and Chris Burden and Hans Haacke who use their images to advance certain political points. I consider the Minimal and Conceptual artists a second group—classical artists. They are more interested in form than in mythmaking. I called myself a classical Romantic, which sounds like a contradiction in terms. What I meant was that I share with the Minimalists and Conceptualists an investigatory attitude. I want to deal with form but not within geometrical or strictly linguistic

86. *Joost's Carnation Landscape.* 1981. Oil on
canvas, 5 x 15'. Collection Sydney and Frances
Lewis, Richmond, Virginia

87. *Very French Painting.* 1982. Oil on canvas, 3
panels, each 39¾ x 39¾". Collection Ellyn and
Sol Dennison, Bernardsville, New Jersey.
Courtesy Galerie Farideh Cadot, Paris

limits. My concerns are with being, not thought, especially being as it enters into history.

Since I listed the various kinds of artists, another has appeared—Romantic mythmakers, who include all the young artists called Neo-Expressionists. Like mine, their art deals with experience and the feelings and so on. Unlike me, they have an interest in defining the kinds of myths that generate action. In this way they come close to the political mythmakers and end up far from the position I've established for myself. As a classical Romantic, I'm looking for something intrinsic in art. Objective beauty. I don't think there is such a thing, but I don't say that there definitely is not. At least an interest in objective beauty gets you outside of the subjective present and into contact with all the kinds of beauty that make up our history. If abstraction and figurative imagery are ultimately the same, just signs of being at varying distances from a subject, perhaps all the varieties of beauty simply indicate that from time to time we have changed our standpoint toward the world. It's possible. With a consciousness of history, an artist can look into those possibilities.

As I got into The Brueghel Series, *my big, multipart painting of 1982–84, I realized that I could have made it twice as complex, four times as complex. There is really no limit to the references it permits. I not only fit a variety of images and styles into the piece but whole realms of thought, attitudes about life. In theory it's an endless project. It included everything I cared about in art—not really, but it felt that way. So I hated to have it leave the studio. It was like emptying the whole universe out of my life.*

I've made my first painting more than once. This was another first painting. Everything I had done up to this point had been too complicated. With The Brueghel Series *I found a way to make my art clear. This work does what I've been trying to do all along: to show the humanity of things, that our works last, that they have meaning for others who come later. Me, in particular.*

The Brueghel Series *convinces me that I can understand all the styles, from Cubism to Van Gogh to Rothko, all of them. My understanding is on my terms, in terms of my art, my handwriting. Whatever the style, every panel looks like my work. I know that. But I also know that the rest of our art, our history, is there too. And the audience is free to understand this history on its own terms.*

To struggle to understand history is so much more touching than self-expression. Working my way through this project was an incredibly moving experience. I found that there were strange, very intimate things to be learned—which painters were left-handed, for instance. But all that is private, between me and the work. Or me and the painters I dealt with. The public meaning of The Brueghel Series *is different. To try to paint the history of painting is to reflect the history of one's learning to perceive, to be in the world. And to show how the culture learned the same things, though of course Western culture didn't have to learn to be in the world. It created our world, so* The Brueghel Series *is about that too—the story of a culture inventing itself.*

There are immense leaps between some of the panels, yet all these styles rose from shared perceptions, a unified way of seeing. The work coheres, though I'm still amazed at the range of individuality. It was almost like raising the dead, revivifying the past. You can't believe in the future unless you believe in the past. My obsession with the history of painting is really an obsession with what's coming. Every panel reflects into the future from a different point in the past. Of course it's ultimately all my work.

Often people look at the work and don't realize that each part of the image quotes a different artist, a different style. To them, the image just looks there. It's just present, here and now. Others do see what I've done. I'm like a transvestite, dressing in the clothes of the thing I adore most. And really looking into its eyes.

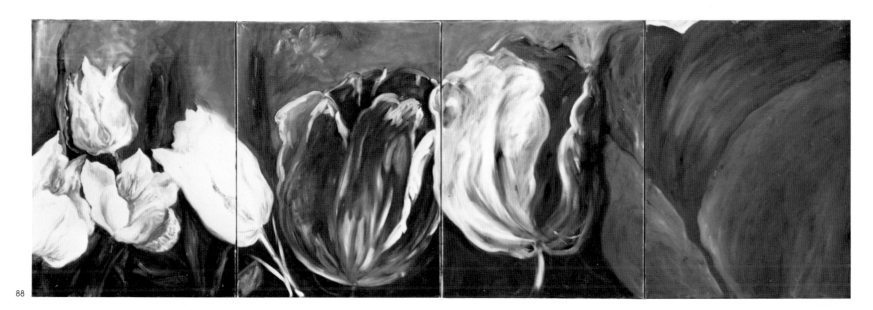

88

88. *Nederlands Landschaft.* 1982. Oil on canvas,
31¾ x 95". The Rivendell Collection

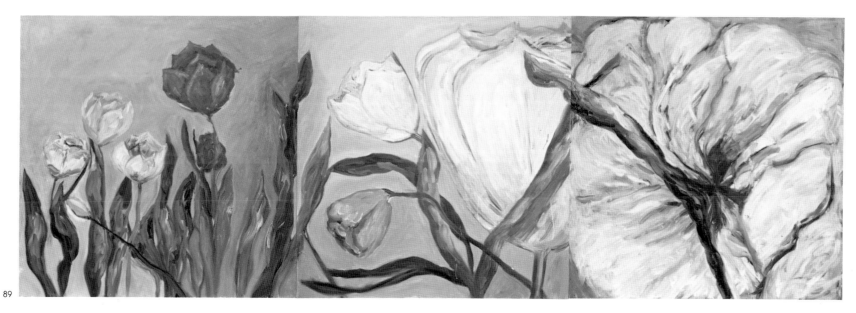

89

89. *Het Nederland Liefling.* 1982. Oil on canvas,
30 x 90". Collection Mrs. Carol Strauss,
Houston. Courtesy McIntosh/Drysdale Gallery,
Washington, D.C.

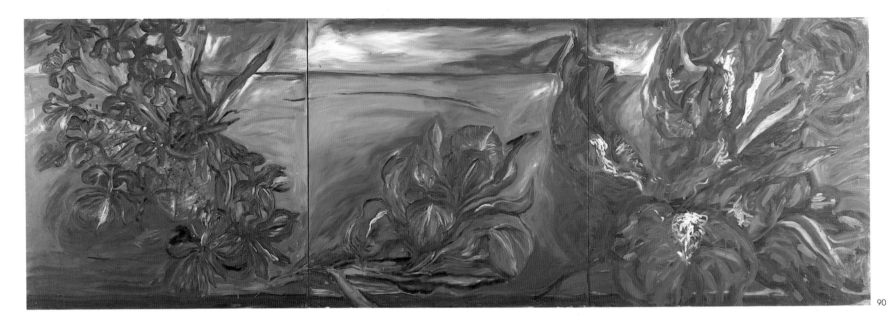

90

90. *Blue Iris on Blue Background,* 1983. Oil on
canvas, 50 x 150". Collection Mr. and Mrs. Lewis
Silberman, Coconut Grove, Florida

91

91. *Technicolor Passion Flower.* 1984. Oil on canvas,
4 x 12'. Art Enterprises Ltd. Private collection,
Chicago. Courtesy The Harcus Gallery, Boston

92

92. *White Tulips*. 1983. Oil on canvas, 50 x 150".
Collection Robert Taubman, Troy, Michigan

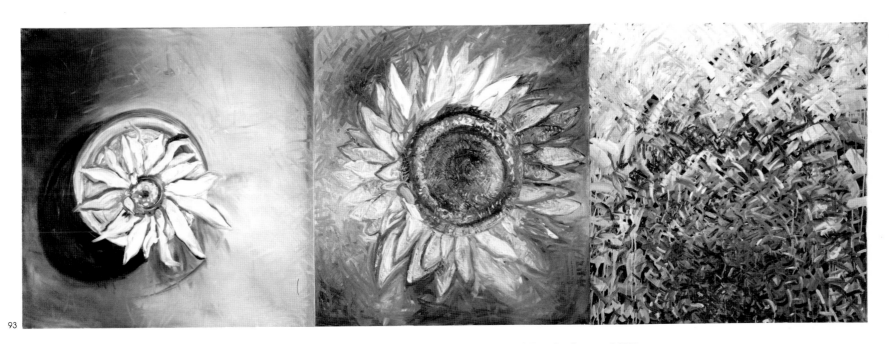

93

93. *Sunflower Triptych with Blue Background*. 1983.
Oil on canvas, 39½ x 118½". Courtesy Michael
Klein, Inc., New York

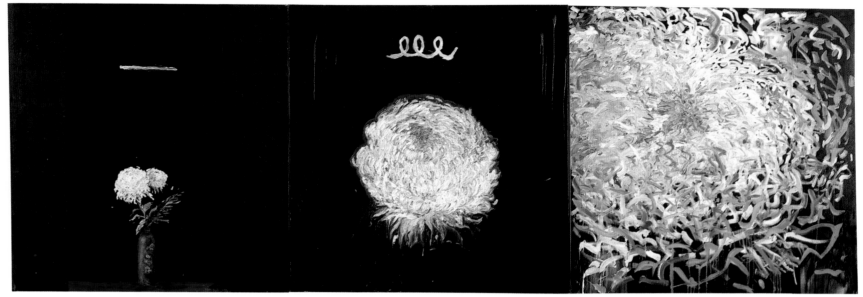

94

94. *Chrysanthemum.* 1981. Oil on canvas, 5 x 15".
Collection Gloria and Leonard Luria, Bal
Harbour Islands, Florida

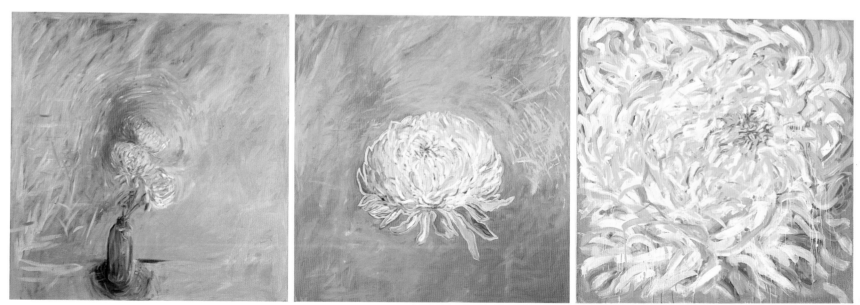

95

95. *Pink Chrysanthemum.* 1984. Oil on canvas,
5 x 15'. Private collection

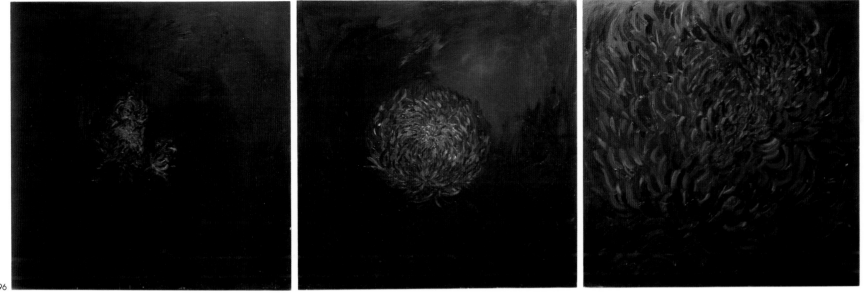

96. *Night Chrysanthemum*. 1984. Oil on canvas,
5 x 15'. Art Enterprises Ltd. Private collection,
Chicago. Courtesy The Harcus Gallery, Boston

97. *White Chrysanthemum (Painting for Ann)*.
1984. Oil on canvas, 5 x 15'. Collection Bank of
America, San Francisco. Courtesy Fuller-
Goldeen Gallery, San Francisco

If we listen to a Symphony of CIMAROSA, the present strain still seems not only to recall, but almost to *renew*, some past movement, another and yet the same! Each present moment bringing back, as it were, and embodying the Spirit of some melody that had gone before, anticipates and seems trying to overtake something that is to come: and the Musician has reached the summit of his art, when having thus modified the Present by the Past, he at the same time weds the Past *in* the Present to some prepared and corresponsive Future. The Auditor's thoughts and feelings move under the same influence: retrospection blends with anticipation, and Hope and Memory... become one Power with a double Aspect. A similar effect the Reader may produce for himself in the pages of History.... The Events and Characters of one age, like the Strains in Music, recall those of another, and the variety by which each is individualized, not only gives a charm and poignancy to the resemblance, but likewise renders the whole more intelligible.

—Samuel Taylor Coleridge, *The Friend*, 1809

CARTER RATCLIFF: The labyrinth of Coleridge's grammar leads us to the heart of a complex intuition: a form, image, or event cannot contain its own significance; to make sense of what happens in music or in history, we must observe each moment's negotiations with its past and its future. Meaning appears as we become conscious of the links that join singular entities in larger patterns. With his remarks on music, Coleridge rejects the belief that meaning descends to us from a transcendent, immutable source. At the same time, he denies that significance is an observable quality like redness or heaviness.

The latter view doesn't acknowledge much difference between the meaning of a thing and traits assigned to it by objective investigation—"objective" indicating "reputably empirical," for this is the view taken by our science and technology. Even the most detached technician admits that fears and desires generate meaning of a sort. Nonetheless, such meaning is not technologically useful; it must be discarded in favor of objectivity's findings. The Positivists of the 1920s and '30s had objections to empiricism, yet they presented a philosophical counterpart to the scientist's skepticism with their claim that all statements not strictly logical are meaningless. That reductive attitude has an equivalent in recent art.

The intentions of the Minimalists do not always make a good match with those of empiricism and logic, yet most of these artists have made the claim that the meaning of a form resides in its physical qualities. Those qualities of shape and color and texture are self-evident in a good form. A bad form obscures such immediacies with symbol, metaphor, suggestions of human gesture, and so on—equivalents of the subjective biases, the failures of method, that scientists, technicians, and their philosophical colleagues would like to exclude from their work. With its aesthetic of "objectivity," Minimalism offers an aesthetic version of the reductivism pervading modern culture.

Though Pat Steir never joined the ranks of the Minimalists, she felt a powerful force in their images. Like Agnes Martin and Sol LeWitt, Steir tried to find the basic elements of art—self-evidently significant forms that give up all their meaning in the moment of perception, images that free us from the "Hope and Memory" that animate Coleridge's experience of music and history. Minimalist art looks for empirical absolutes outside the flow of ordinary time. At the opposite extreme stands art charged with transcendent meaning by a distant, unchanging source. Steir has been drawn in that direction too.

Before the modern period, the Church gave direction to most of art's transcendental yearnings. Though pagan themes began to enter painting and sculpture during the Renaissance, Scriptural subjects remained the rule for large public commissions. Eighteenth-century revolution—political and industrial—broke that rule. The modern period encouraged monuments to the People and the Fatherland, as well as allegorical images of, for example, the Genius of Liberty, Nature Unveiling Herself Before Science, and even Electricity. Yet for two centuries Western culture has resisted the secularizing tendencies that produced such images. We have tried to supply science and even technology with spiritual auras. Though the uncritical faith in empirical method faded early, a practical version of it still sustains our ideals of material progress. Nationalism can also become a religious cult, yet the most persistent forms of modern spirituality center around the individual—for instance, Carl Jung's theories of the collective unconscious.

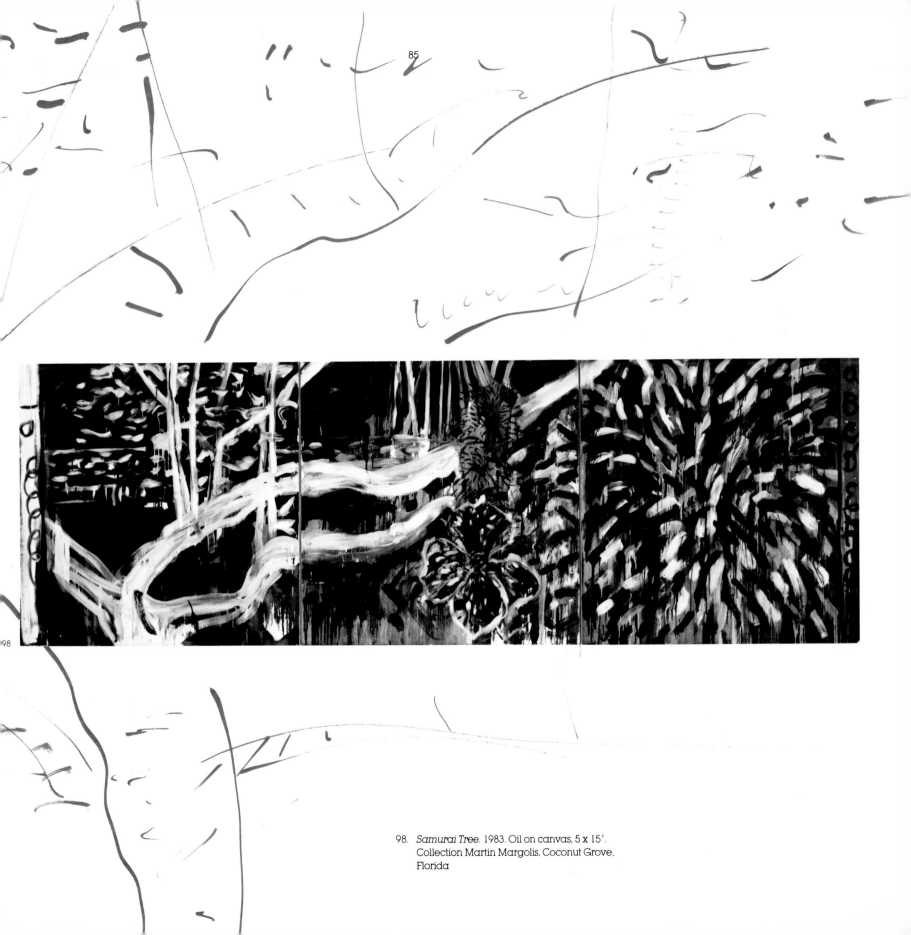

98. *Samurai Tree*. 1983. Oil on canvas, 5 x 15'.
Collection Martin Margolis, Coconut Grove,
Florida

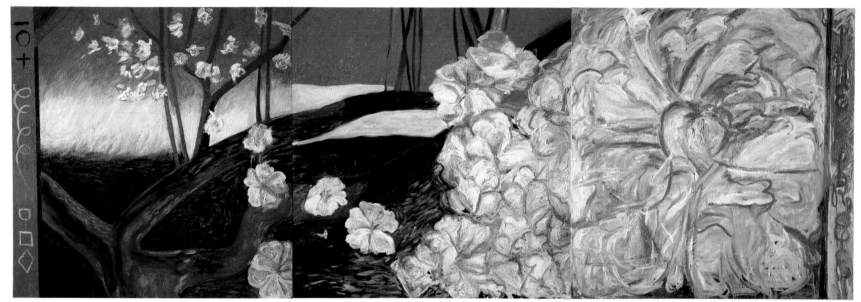

99. *The Tree*. 1982. Oil on canvas, 5 x 15'. Collection
Jean Paul Jungo, Morges, Switzerland

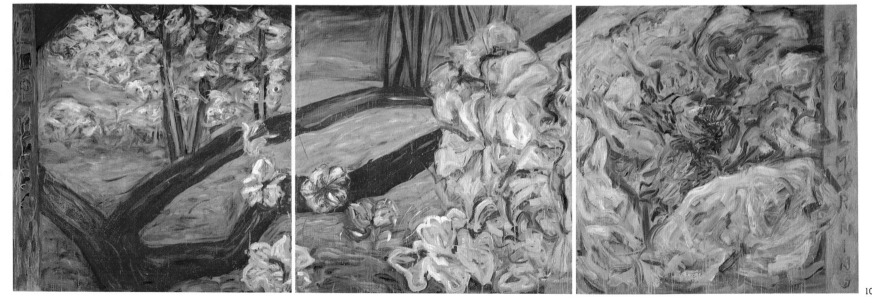

100. *Morning Tree*. 1983. Oil on canvas, 60 x 180".
Collection Joslyn Art Museum, Omaha,
Nebraska. Gift of Sylvia and Jerome I. Cohn in
memory of Betty Kraft Mann and Ruth Rosinsky
Sokolof. Courtesy The Harcus Gallery, Boston

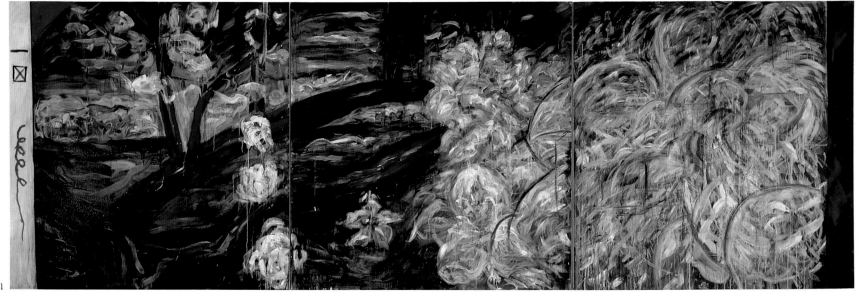

101. *Evening Tree*. 1983. Oil on canvas, 5 x 15′.
Collection General Mills, Minneapolis

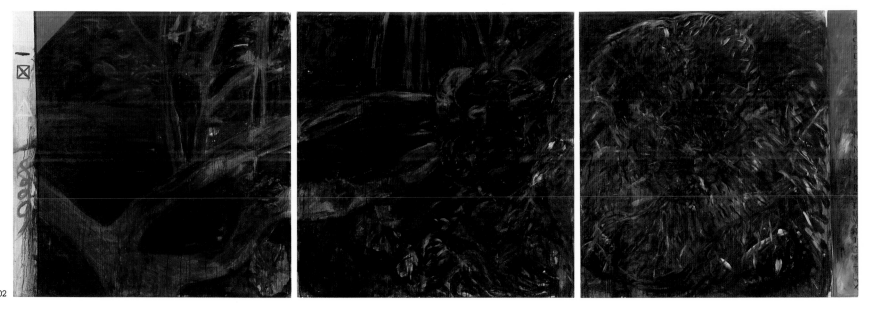

102. *Night Tree*. 1983. Oil on canvas, 5 x 15′. Courtesy
Galerie Eric Franck, Geneva

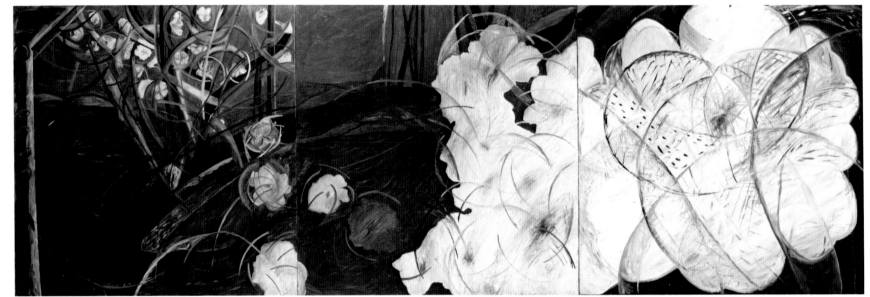

103. *Spring Tree*. 1982. Oil on canvas, 59¾" x 14' 11½".
Collection Cartier Foundation, Paris

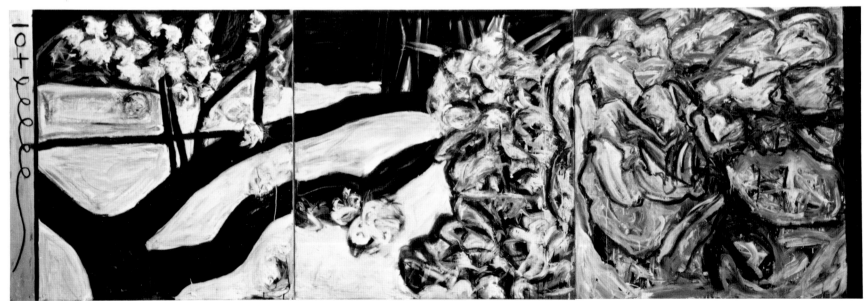

104. *Winter Tree*. 1982. Oil on canvas, 5 x 15'.
Collection Nancy Drysdale, Washington, D.C.

Drawing on a variety of religions and myth cycles, Jungian psychology is eclectic. It proposes a concordance of images as a mirror of the psyche. Jungianism also promises to reveal the individual's links to an eternal body of transcendent meaning. Pat Steir tried at the beginning of her career to make her art a vehicle of that transcendence. When this quasi religion began to look inadequate, a tangle of lofty but irresolvable possibilities, she turned toward Minimalism. Though Steir never became a reductivist, her art made a clear turn from inwardness to the exterior world, from subjectivity to images with an objective aura. This was a large step, but in one respect she had not moved.

Like an empirical finding, a Jungian image occupies its own isolated present. Each implies, and sometimes acknowledges, past and future, but only in a schematic way. "Objective" fact, like Jungian "truth," lets itself be encapsulated in the moment. Neither requires a view of history, only of time as a succession of present moments. So Pat Steir stayed in the present even as she traveled from one pole to the other, from inwardness to her "investigations" of the exterior world and then of the elements of painting. She had no sense of "the Past *in* the Present," as Coleridge puts it, or of any "corresponsive Future" drawing the present out of itself. She had not yet intuited that painting is, or can be, a meditation on history—the medium's, the culture's, and one's own.

Steir replaced a vision of Jungian archetypes with a search for the timeless structures of thought, language, and eventually, painting. Yet she was not trying to submerge her identity in a Neo-Platonic heaven. Steir preserved an ideal of absolute originality, as if she were trying to glimpse an archetypal image of herself—not in Jungian terms, but in terms she had learned from Agnes Martin and other proponents of a pure, unencumbered art. This ideal of the true self preserves for our culture the ancient hope of returning to a Golden Age, a time beyond historical time when the world was—or will be—in its state of original innocence. The 1960s and early '70s were kind to such dreams, but the following years were not.

A decade ago, Steir began to feel the inadequacy of all the myths that had enchanted her, all the archetypes and "objective" truths that had led her from one isolated present to the next. She intuited the currents of history, and felt them turning her toward the modern innovation we obscure with our denials of history: the self.

I don't mean to suggest that individual selves were absent in earlier periods, only that the self as we know it— or, on occasion, would prefer not to know it—is a recent arrival in the history of Western culture. It is the self that appeared with the late-eighteenth-century collapse of the traditional order, a self confronted by a social order whose institutions are all of dubious authority. It is a self driven to seek meaning in *ad hoc* myths—political, aesthetic, psychoanalytical; or to seek refuge from doubt in a world defined by methods claiming "objectivity"—scientific, aesthetic, sociological, and so on, *ad infinitum.*

The art of the last two centuries shows an obsession with origins, whether of the psyche, of culture, or of art itself. Yet we usually construe origins in terms that deny the fragmented state of modern culture. Romantics identified themselves with eternal cycles of nature. Modernists claim to embody the detached patterns of aesthetic progress. These maneuvers help us escape to times out of time, where we take up stances—aesthetic and otherwise— that isolate us in a disconnected present. But that isolation deprives us of our history and, as a consequence, of ourselves.

105. *Red Tree, Blue Sky, Blue Water.* 1984. Oil on
canvas, 3 panels, each 60 x 60". Private
collection, Holland. Courtesy Galerie Barbara
Farber, Amsterdam

106

107

106. *Small Dark Tree (Kandinsky's Tree)*. 1984–85.
Oil on canvas, 37½" x 9' 9½". Collection Mr.
and Mrs. Michael S. Engl. Courtesy Michael
Klein, Inc., New York

107. *Red and Green Tree*. 1984. Oil on canvas, 3
panels, each 25½ x 25½". Collection Yvonne
Ferber, Switzerland. Courtesy Galerie Barbara
Farber, Amsterdam

Most artists quickly find their ahistorical niche. Steir did not. Her restlessness eventually drove her out of the bright glare of the isolated moment into the subtler light of the past. She only became conscious of that light when she had spent several winters on the Binnenkant in Amsterdam. Rembrandt lived across the canal, and Steir's house gives her a view of the city much like the one he had. She identified herself with him, a familiar tactic. Then she sensed her difference from this figure from an earlier century. She was coming face-to-face with herself. Steir found herself coming alive to the inexhaustibly rich mixture of sameness and difference, self-reflection and otherness, that constitutes the past. As our most adventurous artists have done from the outset of modernity, she learned history by making it over on her own terms. She was not simply advancing a claim on the narrow history of art. She had begun to envision, through her painting, her relationship to modern culture.

In 1818 John Keats said, "That which is creative must create itself." This is the work of the imagination, Coleridge's "shaping spirit." Before the modern period, there is little place for imagination in theories of art. Early moderns like Coleridge and Keats made the imagination central, its command over the forms of language and art emblematic of a power to shape the world and its meanings. Romantic confidence has not survived modern events. Yet we have not entirely abandoned the imagination to the realm of worn-out notions.

We still know what Coleridge means when he talks of "the Auditor's thoughts and feelings" finding their way into the flow of symphonic music, that intricate web of past, present, and future. Coleridge is intelligible when he compares the experience of making sense of music to the play of "Hope and Memory" as they find meaning in history's tangle. This is not a simple matter of discovery. Coleridge's faith, and ours, requires the imagination to be active. He calls it the "creative" faculty not because it possesses godlike omnipotence but because, faced with givens, the imagination endows them with significance. In the process, we create our places in the flow of events. We create ourselves, or we struggle to do so. When Pat Steir transposes that struggle into the medium of painting, she offers us emblems of selfhood confronting the history that brought it into being. She offers a vision of us and our culture.

108

108. *Yellow Light Tree*. 1985. Oil on canvas, 48 x 144".
Courtesy Michael Klein, Inc., New York, and
Galerie Eric Franck, Geneva

109

109. *Zen Tree*. 1983. Oil on canvas, 5 x 15'. Courtesy
Fuller-Goldeen Gallery, San Francisco

110. *Untitled (Mirage).* 1985. Acrylic on 2 nylon scrims.
Installation, "Promenades" Exhibition, Parc Lullin,
Genthod, Switzerland

111

111. *The Brueghel Poster (After Brueghel's Flower Piece in Blue Vase, 1599. Collection Kunsthistorisches Museum, Vienna).* 1983. Pencil on poster, 28⅜ x 22¼".

112. *The Brueghel Series (A Vanitas of Style)
Monochrome: 2nd Version.* 1982–85. Oil on
canvas, 16 panels, each 26½ x 21″. Collection
Agnes Gund Saalfield, New York

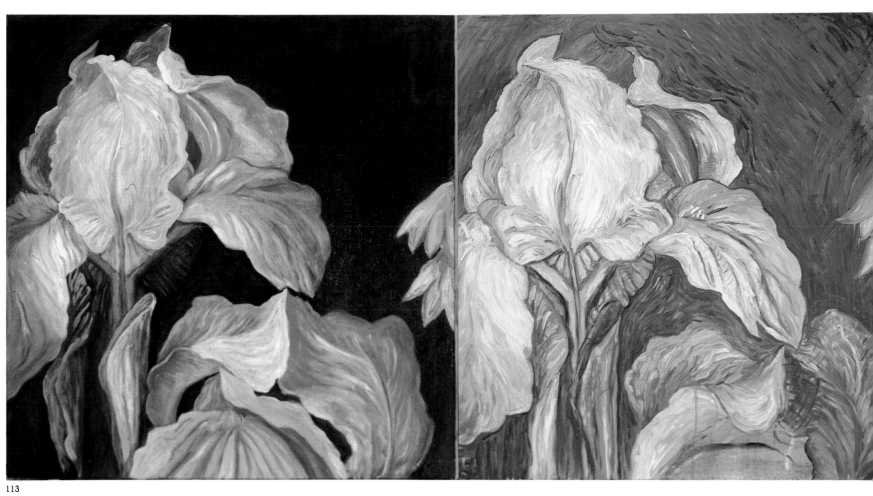

113

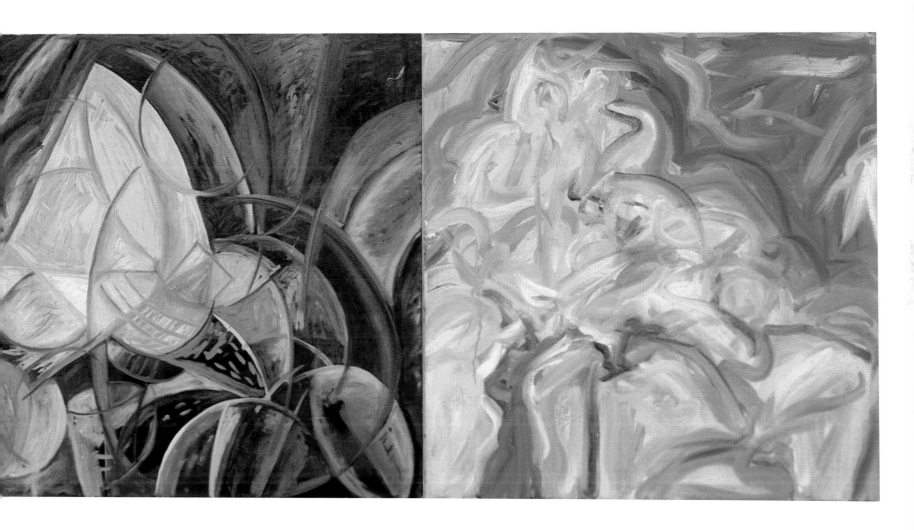

113. *Study for the Brueghel Series: Iris in Four Parts.*
1982. Oil on canvas, 30 x 120". Collection
Whitehead Institute for Biomedical Research,
Cambridge, Massachusetts

114. *Tulip and Anemone in 6 Parts.* 1983. Oil on
canvas, 32 x 169½". Collection Royal Sonesta
Hotel, Cambridge, Massachusetts

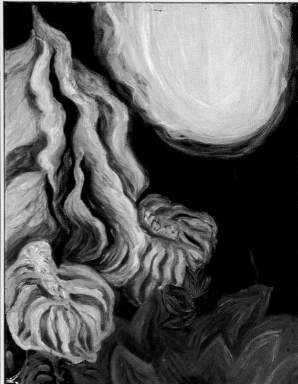

114

115

115. *Study for the Brueghel Series: Peony.* 1982. Oil on
canvas, 24 x 120". Collection Dr. Jan Clee,
Portsmouth, New Hampshire

116. *Study for the Brueghel Series: Untitled.* 1983. Oil
on canvas, 8 panels, each 36 x 15″. Collection
Edna S. Beron, New Jersey

117. *Study for the Brueghel Series: Triptych (After Manet)*. 1982. Oil on canvas, 3 panels, each 27½ x 27½". Collection Marilena Bonomo, Bari, Italy

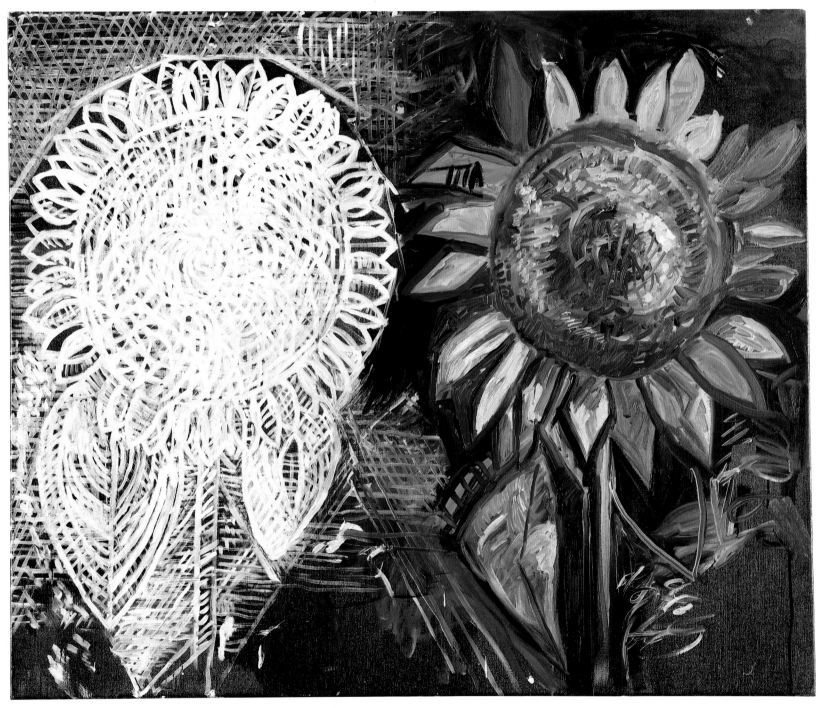

118

118. *Amsterdam Series: Drawing Lesson with
Sunflower.* 1984. Oil on canvas, 39½ x 47½".
Courtesy Fuller-Goldeen Gallery, San Francisco

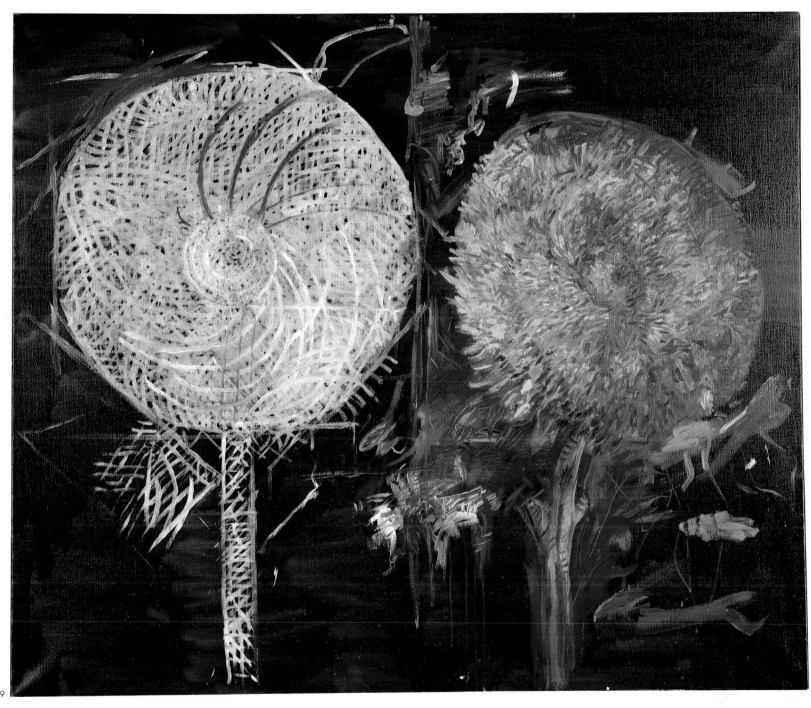

119. *Amsterdam Series: Drawing Lesson with Orange Sunflower.* 1984. Oil on canvas, 39½ x 47½". Private collection, Saint Paul, Minnesota

120. *Study for the Brueghel Series: Gladiola Drawing Lesson.* 1983. Oil on canvas, 39½ x 47". Collection Mr. and Mrs. M. Engler, Minneapolis

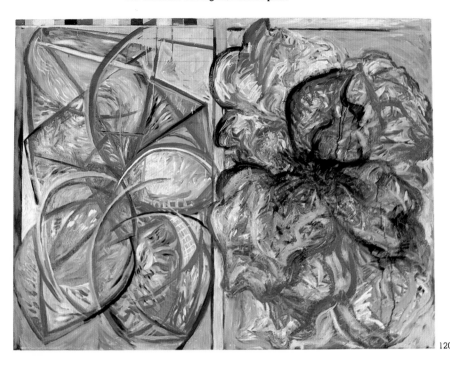

120

122. *Study for the Brueghel Series: Red and Brown.* 1984. Oil on canvas, 39¼ x 39¼". Courtesy Galeria Marilena Bonomo, Bari, Italy

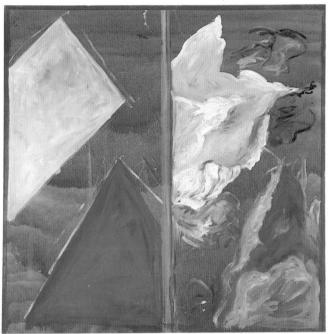

122

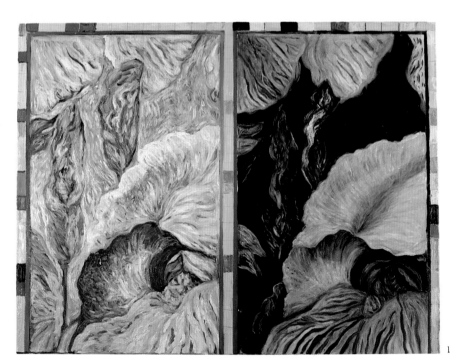

121

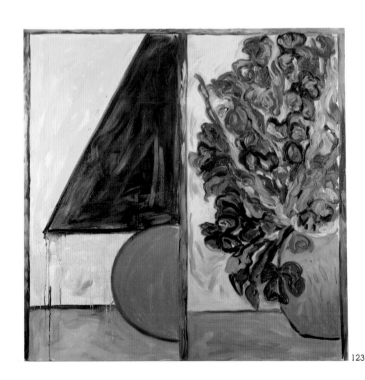

123

121. *Study for the Brueghel Series: Iris in Two Lights.* 1983. Oil on canvas, 39½ x 47". Collection Jean Paul Jungo, Morges, Switzerland. Courtesy Galerie Eric Franck, Geneva

123. *Drawing Lesson After Van Gogh.* 1983. Oil on canvas, 48 x 48". Collection Mr. J. Sistovaris, Geneva. Courtesy Galerie Eric Franck, Geneva

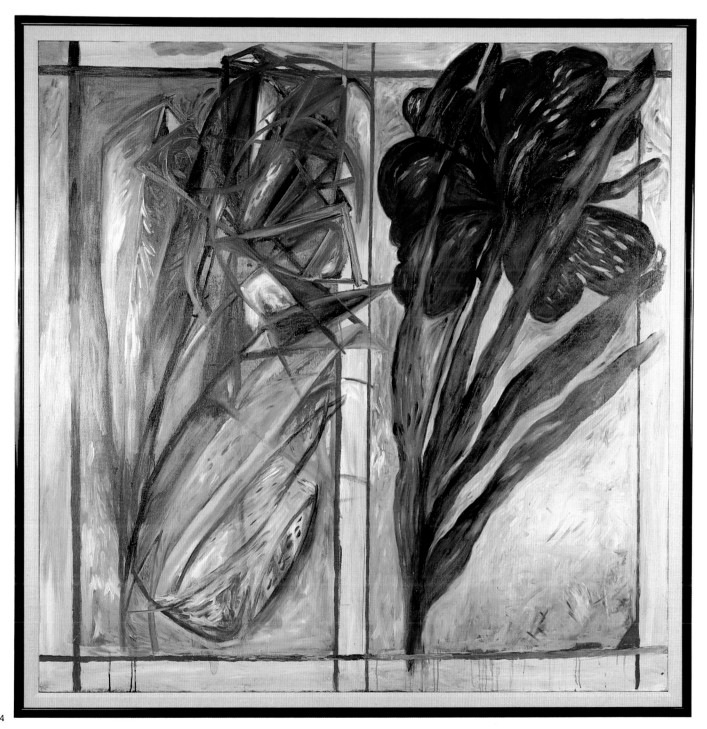

124

124. *Drawing Lesson with Iris.* 1983. Oil on canvas,
60 x 60". Collection Carnegie Center, Princeton

125

125. *The Brueghel Series (A Vanitas of Style) Monochrome: 1st Version.* 1982–84. Oil on canvas, 16 panels, each 28½ x 22½". Courtesy American Express Company Collection

126. *The Brueghel Series (A Vanitas of Style)
Polychrome.* 1982–84. Oil on canvas, 64 panels,
each 28½ x 22½". Courtesy Michael Klein, Inc.,
New York

Key on overleaf

1	2	3	4	5	6	7	8
9	10	11	12	13	14	15	16
17	18	19	20	21	22	23	24
25	26	27	28	29	30	31	32
33	34	35	36	37	38	39	40
41	42	43	44	45	46	47	48
49	50	51	52	53	54	55	56
57	58	59	60	61	62	63	64

1. Contemporary style of Pat Steir, American, b. 1940 2. Art Nouveau style, 1880–1910 3. School of Piet Mondrian, Dutch, 1872–1944 4. Sandro Botticelli, Italian, 1444–1510 5. Jan Brueghel the Elder, Flemish, 1568–1625 6. Max Ernst, German, 1891–1976 7. Franz Kline, American, 1910–1962 8. Ad Reinhardt, American, 1913–1967

9. Sol LeWitt, American, b. 1928 10. Ellsworth Kelly, American, b. 1923 11. Late style of Marsden Hartley, American, 1877–1943 12. Early style of Marsden Hartley, American, 1877–1943 13. Pablo Picasso, Spanish, 1881–1973 14. Albert Pinkham Ryder, American, 1847–1917 15. Jean-Baptiste Chardin, French, 1699–1779 16. Antoine Watteau, French, 1684–1721

17. Jackson Pollock, American, 1912–1956 18. Background in style of James A. M. Whistler, American, 1834–1903 19. Arthur G. Dove, American, 1880–1946 20. Alexei von Jawlensky, Russian, 1864–1941 21. Paul Cézanne, French, 1839–1906 22. Early style of Henri Matisse, French, 1869–1954 23. Richard Diebenkorn, American, b. 1922 24. Cy Twombly, American, b. 1929

25. Clyfford Still, American, 1904–1980 26. Odilon Redon, French, 1840–1916 27. Georgia O'Keeffe, American, b. 1887 28. Byzantine style, 330–1453 29. J. A. D. Ingres, French, 1780–1867 30. Vittore Carpaccio, Italian, 1455–1526 31. Hans Hofmann, American, 1880–1966 32. Kazimir Malevich, Russian, 1878–1935

33. Arshile Gorky, American, 1905–1948 34. Philip Guston, American, 1913–1980 35. Max Beckmann, German, 1884–1950 36. Edgar Degas, French, 1834–1917 37. Willem de Kooning, American, b. 1904 38. Claude Monet, French, 1840–1926 39. Synchromist style, 1913–1925 40. Georg Baselitz, German, b. 1938

41. De Stijl, 1917–1932 42. Abstract Expressionist style, 1946–1960s 43. Gustave Courbet, French, 1819–1877 44. Edouard Manet, French, 1832–1883 45. Willem de Kooning, American, b. 1904 46. Vincent van Gogh, Dutch, 1853–1890 47. Japonisme, 1854–1910 48. Early style of Pat Steir, American, b. 1940

49. Mark Rothko, American, 1903–1970 50. Joseph M. W. Turner, English, 1775–1851 51. Rembrandt van Rijn, Dutch, 1606–1669 52. Cubist style, 1907–1925 53. Earliest style of Henri Matisse, French, 1869–1954 54. Vassily Kandinsky, Russian, 1866–1944 55. Futurist style, 1909–1916 56. Brice Marden, American, b. 1938

57. Flemish, 15th-century style 58. German, 14th-century style 59. Paul Gauguin, French, 1848–1903 60. Jacques-Louis David, French, 1748–1825 61. Late style of Henri Matisse, French, 1869–1954 62. Kazimir Malevich, Russian, 1878–1935 63. Terry Winters, American, b. 1949 64. Jean Michel Basquiat, American, b. 1960

Born 1940, Newark, N.J.
Lives and works in New York and Amsterdam

Solo Exhibitions

1964 Terry Dintenfass Gallery, New York

1969 Bienville Gallery, New Orleans

1971 Graham Gallery, New York

1972 Douglass College, Rutgers University, New Brunswick, N.J.
Paley & Lowe, Inc., New York

1973 Ball State University Art Gallery, Muncie, Ind.
Corcoran Gallery of Art, Washington, D.C.
Max Protetch Gallery, Washington, D.C.

1975 Fourcade, Droll, Inc., New York
John Doyle Gallery, Paris
State University of New York, Oneonta

1976 The Art Gallery, University of Maryland, College Park
Galerie Farideh Cadot, Paris
Morgan Thomas Gallery, Santa Monica, Cal.
Otis Art Institute, Los Angeles
White Gallery, Portland State University, Ore.
Xavier Fourcade, Inc., New York

1977 Carl Solway Gallery, Cincinnati

1978 Art School for Children, Birmingham, Ala.
Droll/Kolbert Gallery, New York
Galeria Marilena Bonomo, Bari, Italy
Galerie Farideh Cadot, Paris

1979 Galerie Farideh Cadot, Paris

1980 Droll/Kolbert Gallery, New York
Galerie d'Art Contemporain, Geneva
Galerie Farideh Cadot, Paris
Max Protetch Gallery, New York

1981 Bell Gallery, List Art Center, Brown University, Providence, R.I. Cat.: *Pat Steir.* September 16–October 11, 1981. Statement by Pat Steir
Crown Point Press Gallery, Oakland, Cal. Cat.: *Pat Steir Etchings and Paintings.* November 14–December 31, 1981. Pat Steir in conversation with Kathan Brown
Galeria Marilena Bonomo, Bari, Italy
Galerie Farideh Cadot, Paris
Galleriet, Lund, Switzerland
Marianne Deson Gallery, Chicago
Max Protetch Gallery, New York

1982 Eason Gallery, Santa Fe
Galerie Annemarie Verna, Zurich
Galerie Farideh Cadot, Paris
Nina Freudenheim Gallery, Buffalo (watercolors)

1983 Contemporary Arts Museum, Houston; traveled to Lowe Art Museum, Coral Gables, Fla.; The Contemporary Arts Center, Cincinnati. Cat.: *Arbitrary Order: Paintings by Pat Steir.* May 27–July 17, 1983. Foreword by Linda L. Cathcart. Essay by Marti Mayo. Conversation with Pat Steir by Ted Castle
Crown Point Press, New York (monoprints)
Fuller Goldeen Gallery, San Francisco
Galeria Marilena Bonomo, Bari, Italy
Gloria Luria Gallery, Bay Harbor Islands, Fla.
The Harcus Gallery, Boston
McIntosh/Drysdale Gallery, Houston
Max Protetch Gallery, New York
Spencer Museum of Art, University of Kansas, Lawrence; traveled to University Art Museum, California State University, Long Beach; Contemporary Arts Museum, Houston; The Wellesley College Museum, Wellesley, Mass.; Brooks Memorial Art Gallery, Memphis, Tenn. Cat.: *Form, Illusion, Myth: The Prints and Drawings of Pat Steir.* January 17–February 27, 1983. Essays by Elizabeth Broun and Joan Simon. Interview with and fable by Pat Steir

1984 The Brooklyn Museum, New York. Cat.: *The Brueghel Series (A Vanitas of Style).* December 6, 1984–February 18, 1985. Essay by Charlotta Kotik. Notes by Pat Steir
Galerie Barbara Farber, Amsterdam
Galleriet, Lund, Sweden
Nina Freudenheim Gallery, Buffalo
Real Art Ways, Hartford, Conn.
Signet Gallery, St. Louis
Van Straaten Gallery, Chicago

1985 Cincinnati Art Museum. "New Drawings"
Dolan/Maxwell Gallery, Philadelphia. Cat.: *Pat Steir: Major Prints & Drawings.* January 1985. Introduction by Barry Walker
Galerie Eric Franck, Geneva
Joslyn Art Museum, Omaha. Cat.: *Beyond Style.* August 3–September 15, 1985. Essay by Holliday T. Day
Minneapolis College of Art and Design. Cat.: *The Mega Painting: Pat Steir's "The Brueghel Series."* April 5–May 2, 1985. Essay by Thomas McEvilley
Philadelphia College of Art. "Pat Steir: Prints/Printmaking"
University Art Museum, Berkeley, Cal. "Matrix"

1986 Dallas Museum of Fine Arts, Dallas
Fuller Goldeen Gallery, San Francisco
Honolulu Academy of Arts
John C. Stoller & Co., Minneapolis

Group Exhibitions

1963　The High Museum of Art, Atlanta, Ga.

1964　Finch College Museum of Art, New York
The Museum of Modern Art, New York
Philadelphia Museum of Art

1966　Terry Dintenfass Gallery, New York

1969　Graham Gallery, New York

1970　French & Company, New York

1971　Glauber Poons Gallery, Amsterdam
Graham Gallery, New York
Paley & Lowe, Inc., New York. "Three Paintings"

1972　Aldrich Museum of Contemporary Art, Ridgefield,
Conn. Cat.: *Exhibitions Fall 1972; Selection from the
Aldrich Museum Collection and the Invitational
Showing of "Paintings on Paper."* September 17–
December 17, 1972. Introduction by Larry Aldrich
Art Lending Service, The Museum of Modern Art, New
York. "Landscapes"
Bard College, Annandale-on-Hudson, N.Y. "Paintings on
Paper"
Contemporary Arts Center, Cincinnati. "Alternative
Landscapes"
Corcoran Gallery of Art, Washington, D.C. "Seven Young
Artists: Works on Paper"
Fine Arts Center, University of Rhode Island, Kingston.
"Three Painters"
Indianapolis Museum of Art. Cat.: *Painting and Sculp-
ture Today, 1972.* April 26–June 4, 1972
Institute of Contemporary Art, University of Pennsyl-
vania. Cat.: *The Topography of Nature: The Micro-
cosm and Macrocosm.* March 22–April 27, 1972
Whitney Museum of American Art, New York. Cat.: *40th
Annual Exhibition.* January 25–March 19, 1972

1973　Cusack Gallery, Houston. "Drawings"
Institute of Contemporary Art, University of Pennsyl-
vania. Cat.: *Six Visions.* October 10–November 25,
1973. Introduction by Suzanne Delehanty
The Museum of Modern Art, New York
New York Cultural Center, New York. Cat.: *Women
Choose Women.* January 1973. Essay by Lucy R.
Lippard
Whitney Museum of American Art, New York. Cat.:
American Drawing 1963–1973. May 25–June 22,
1973. Essay by Elke Solomon
Whitney Museum of American Art, New York. "Biennial
Exhibition: Contemporary American Art"

1974　The Civic Center Museum, The Philadelphia Civic Cen-
ter. "Woman's Work: American Art 1974"
Indianapolis Museum of Art. Cat.: *Painting and Sculp-
ture Today, 1974.* May 22–July 14, 1974. Preface by
Carla Weinhardt. Introduction by Richard Warrum
Institute of Contemporary Art, Boston. Cat.: *Joan Snyder
and Pat Steir.* October 10–November 12, 1974. Essay
by Kenneth Baker
Loretta Yarlow Fine Arts, Ltd., Toronto. "Inaugural
Exhibition"
The Saidye Bronfman Centre, Montreal. "28 Painters of
the New York Avant-Garde '74"
Whitney Museum of American Art, Downtown Branch,
New York. "People and Places"

1975　The American Federation of Arts, New York. Cat.: *Recent
Drawings.* June 15, 1975–October 10, 1976. Introduc-
tion and essay by Elke Solomon
Fourcade, Droll, Inc., New York. "Group Show"
Gallery 210, University of Missouri, St. Louis. Cat.: *Amer-
ican Women Printmakers.* October 1975. Essay by
Sylvia Solochek Walters
Max Protetch Gallery, Washington, D.C. "Art That
Involves Words"
Whitney Museum of American Art, Downtown Branch,
New York. "25 Stills"

1976　Indianapolis Museum of Art. Cat.: *Painting and Sculp-
ture Today, 1976.* June 9–July 18, 1976
Marion Koogler McNay Art Institute, San Antonio, Tex.
Cat.: *American Artists '76: A Celebration.* May 23–
August 1, 1976. Foreword by John P. Leeper. Essay by
Alice C. Simkins
Max Protetch Gallery, Washington, D.C.
Philadelphia College of Art Gallery. Cat.: *Private Nota-
tions: Artists' Sketchbooks II.* October 23–November
24, 1976. Essay by Janet Kardon. Statements by the
artists
The University Art Museum, California State University,
Long Beach. Cat.: *16 Projects/4 Artists.* September 12,
1976–March 25, 1977. Essays by Lawrence Alloway,
Kevin Boyle, Stacy Dukes, William Scurlock, and
Diane Vanderlip

1977　Archer M. Huntington Gallery, University Art Museum,
The University of Texas at Austin. Cat.: *New in the Sev-
enties.* August 21–September 25, 1977. Statements by
Donald B. Goodall and Fred Seabolt
The Art Institute of Chicago. Cat.: *Drawings of the 70s.*
March 9–May 1, 1977. Introduction by Harry Joachim
Madison Art Center, Wis. Cat.: *Recent Works on Paper by
American Artists.* December 7, 1977–January 15, 1978.
Introduction by Victor Kord. Statement by Joseph
Wilfer
Museum of Contemporary Art, Chicago, *A Survey of
Prints (1970–1977).* November 18, 1977–January 8,
1978. Introduction by Judith Russi Kirshner. Interview
of Jack Lemon by Pauline Saliga
The Museum of Modern Art, New York. "America Drawn
and Matched"

Nelson Gallery of Art, Atkins Museum of Fine Arts, Kansas City, Mo. "New Print Acquisitions"

New York State Women's Meeting, Albany. "Women in Art: Working Papers"

P.S. 1, Institute for Art and Urban Resources, New York. "A Painting Show"

San Diego Museum of Art, Cal. Cat.: *Invitational American Drawing Exhibition.* September 17–October 30, 1977. Introduction by G. A. Santangelo

Weatherspoon Art Gallery, University of North Carolina, Greensboro. Cat.: *Art on Paper, 1977.* November 13–December 18, 1977

Whitney Museum of American Art, New York. Cat.: *1977 Biennial.* February 15–April 3, 1977. Foreword by Tom Armstrong. Introduction by Barbara Haskell, Marcia Tucker, and Patterson Sims

1978　Albright-Knox Art Gallery, Buffalo. Cat.: *American Painting of the 1970s.* December 8, 1978–January 14, 1979. Foreword by Robert T. Buck, Jr. Essays by Linda L. Cathcart

Janus Gallery, Los Angeles. "Drawing Explorations 1930–1978"

Touchstone Gallery, New York. "Beyond the Canvas … Artists' Books and Notations"

University Art Museum, University of California, Santa Barbara. Cat.: *Contemporary Drawing/New York.* February 22–March 26, 1978. Foreword and essay by Phyllis Plous

1979　Art Museum, The University of New Mexico, Albuquerque. "Lithography: A Sense of Scale"

The New Museum, New York; traveled to Europe under the auspices of the International Communications Agency, Washington, D.C. Cat.: *The 1970's: New American Painting.* June 15, 1979–February 15, 1981. Essays by Alan Schwartzman and Kathleen Thomas

Union Carbide Building, Inner City Scholarship Fund, New York. "Art from Corporate Collections"

Whitney Museum of American Art, New York. "Decade in Review: Selections from the 1970s Permanent Collection"

1980　The Brooklyn Museum, New York. Cat.: *American Drawings in Black & White: 1970–1980.* November 22, 1980–January 18, 1981. Essay by Gene Baro

Max Protetch Gallery, New York

Nina Freudenheim Gallery, Buffalo. "Drawings"

Walker Art Center, Minneapolis. Cat.: *Artist and Printer: Six American Print Studios.* December 7, 1980–January 18, 1981

Whitney Museum of American Art, New York. "American Painting of the 60s and 70s: The Real, the Ideal, the Fantastic: Selections from the Whitney Museum of American Art"

1981　Art Lending Service, The Museum of Modern Art, New York. "A Penthouse Aviary"

Città di Noto, Siracusa, Italy. Cat.: *Aljofre Barroco.* May 25–June 13, 1981. Introduction by Ernesto Rizza and Antonio Vella. Statement by Demetrio Paparoni

Clark-Benton Gallery, Santa Fe. "New York News"

Gloria Luria Gallery, Bay Harbor Islands, Fla. "Pat Steir—Denise Green"

Jacksonville Museum of Art and the University of South Tampa, Fla. Cat.: *Currents—A New Mannerism.* December 11, 1981–January 24, 1982. Essay by Margaret Miller

Nina Freudenheim Gallery, Buffalo. "Paper Work"

The Patrick Gallery, Austin, Tex. "Rigors"

Sardoni Art Gallery, Wilkes College, Wilkes-Barre, Penn. "A Range of Contemporary Drawings"

Weatherspoon Art Gallery, University of North Carolina at Greensboro. Cat.: *Art on Paper, 1981.* November 15–December 13, 1981. Foreword by Scott C. Keener

Wesleyan University Art Gallery and Davison Art Center, Wesleyan University, Middletown, Conn.; traveled to University Art Museum, California State University, Long Beach; Ackland Art Museum, Chapel Hill, N.C.; Museum of Art, Fort Lauderdale, Fla.; Everhart Museum, Scranton, Penn.; Grey Art Gallery, New York University, New York. Cat.: *No Title: The Collection of Sol LeWitt.* October 21–December 20, 1981. Preface and introduction by John T. Paoletti. Statements by Sol LeWitt, Andrea Miller-Keller, and Tracy Atkinson

1982　Aldrich Museum of Contemporary Art, Ridgefield, Conn. "Post-Minimalisms"

Crown Point Press Gallery, Oakland, Cal. Cat.: *Representing Reality: Fragments from the Image Field: An Exhibition of Etchings and Woodblock Prints by Gunter Brus, Francesco Clemente, Joel Fisher, Robert Kushner, Pat Steir, William T. Wiley.* August–September, 1982. Essay by Kathan Brown

DuBose Galleries, Houston, Tex. "Flowers and Gardens in American Painting"

Fuller Goldeen Gallery, San Francisco, Cal. "Paintings"

John C. Stoller & Company, Minneapolis. "New American Painting III"

Madison Art Center, Wis. "New American Graphics 2"

Mulvane Art Center, Washburn University, Topeka, Kans. "Shea Gordon, Pat Steir, and Denise Green"

Musée d'Art Contemporain, Paris. "L'Art Baroque"

Vassar College Art Gallery, Poughkeepsie, N.Y. "Geometric Art at Vassar"

1983　A Space, Toronto. "Sex and Representation"

Barbara Mathes Gallery, New York. "Inaugural Exhibition"

Centre Culturel le Parvi, Tarbes, France

Gallerie Annemarie Verna, Zurich. "When Art Becomes Book/When Books Become Art"

The Harcus Gallery, Boston. "Ornamentalism"

Impressions Gallery, Boston. "Tulip Time"

Musée d'Art de Toulon, France. "Recent Acquisitions"

Musée d'Art Moderne de la Ville de Paris. "ARC Exhibition"

Museum of Art, Rhode Island School of Design, Providence. "Collector's Choice"

The Museum of Modern Art, New York. "Recent Acquisitions"

The New Museum of Contemporary Art, New York. Cat.: *Language, Drama, Source and Vision.* October 8–November 27, 1983. Essay by Marcia Tucker

The Port of History Museum at Penn's Landing, Philadelphia. "Printed by Women: A National Exhibition of Photographs and Prints"

Whitney Museum of American Art, New York. Cat.: *1983 Biennial Exhibition.* March 15–May 22, 1983. Preface by John G. Hanhardt, Barbara Haskell, Richard Marshall, and Patterson Sims

1984 Bank of America World Headquarters, San Francisco. Cat.: *Highlights: Selections from the BankAmerica Corporation Art Collection.* May 1984. Statement by Bonnie Earls-Solari

Barbara Mathes Gallery, New York. "Fauna, Flora, etc."

Barbara Toll Fine Arts, New York. "Drawings"

Bard College Museum, Annandale-on-Hudson, N.Y. "Contemporary Triptychs"

Cable Gallery, New York

CIGNA Corp., Hartford, Conn. "Landscapes"

Diane Brown Gallery, New York. "The Success of Failure"

Dowd Fine Arts Center Gallery, State University of New York, Cortland; traveled to Truman Gallery, Indiana State University, Terre Haute. Cat.: *The New Culture: Women Artists of the Seventies.* Essay by Arlene Raven

Fuller Goldeen Gallery, San Francisco. "50 Artists/50 States"

The Harcus Gallery, Boston. "Three Painters, Three Decades" (Lee Krasner, Joan Mitchell, Pat Steir)

Hirshhorn Museum and Sculpture Garden, Smithsonian Institution, Washington, D.C. Cat.: *Content: A Contemporary Focus, 1974–1984.* October 4, 1984–January 6, 1985. Foreword by Abram Lerner. Essays by Howard N. Fox and Miranda McClintic

McIntosh/Drysdale Gallery, Houston. "Four Painters: Mangold, Scully, Steir, Zakanitch"

Monique Knowlton Gallery, New York. "Ecstasy"

Nina Freudenheim Gallery, Buffalo. "Drawing: New Dimensions"

Pace Editions, New York

Pratt Manhattan Center Gallery, New York. "Beauties and Beasts"

Sidney Janis Gallery, New York. Cat.: *American Women Artists, Part II: The Recent Generation.* February 11–March 3, 1984

University Art Gallery, State University of New York, Binghamton. "Vision and Conscience"

Whitehead Institute for Biomedical Research, Cambridge, Mass. Cat.: *Whitehead Institute Art Collection.* Statement by Stephen Johnson and Lucille Aptekar (no public exhibition)

Whitney Museum of American Art, New York; traveled to North Carolina Museum of Art, Raleigh; La Jolla Museum of Contemporary Art, Cal.; Sheldon Memorial Art Gallery, University of Nebraska, Lincoln; Center for Fine Arts, Miami. Cat.: *Art of the Seventies.* March 10–April 22, 1984. Essay by Richard Marshall

1985 Aorta, Amsterdam. Cat.: *Doppelgänger.* April 20–May 18, 1985. Organized by Paul Groot

Centre d'Art Contemporain, Geneva. "Promenades"

Independent Curators Incorporated, New York. Cat.: *Large Drawings.* January 15–February 17, 1985. Essay by Elke Solomon

The Hudson River Museum, Yonkers, N.Y. "A New Beginning: 1968–1978"

Jeffrey Hoffeld & Co., New York. "With An Eye to Nature"

Laforet Museum, Tokyo; traveled to Tochigi Prefectural Museum of Fine Arts, Japan; Tasaki Hall Espace Media, Kobe, Japan. "New York Now: Correspondences"

The Museum of Modern Art, New York. Cat.: *New Work on Paper 3.* Essay by Bernice Rose

New Woman Magazine, New York. "Six Women Artists"

The New York Studio School. "From Organism to Architecture"

Richard Kuhlenschmidt Gallery, Los Angeles. "Jonathan Borofsky, Douglas Huebler, William Leavitt, Pat Steir, William Wegman Drawings"

Sordoni Art Gallery, Wilkes College, Wilkes-Barre, Penn. "New Expressive Landscape"

Vanguard Gallery, Philadelphia. "Appropriations: Black and White"

Bibliography

1964 Campbell, Lawrence. "Pat Steir," *Art News*, vol. 63, no. 7 (November 1964), p. 22

1971 Brown, Gordon. "Pat Steir: Paley & Lowe," *Artforum*, vol. 45, no. 4 (February 1971), pp. 65–66

Gollin, Jane. "Pat Steir," *Art News*, vol. 69, no. 10 (February 1971), p. 26

1972 Baker, Kenneth. "The World Within Around Us," *Christian Science Monitor*, November 17, 1972

Bordon, Lizzie. "Pat Steir: Paley & Lowe," *Artforum*, vol. 11, no. 4 (December 1972), p. 88

Canaday, John. "Painting by Pat Steir at Paley & Lowe," *The New York Times*, September 30, 1972, p. 27

Crimp, Douglas. "Pat Steir," *Art News*, vol. 71, no. 6 (October 1972), pp. 82–83

Hughes, Robert. "Myths of 'Sensibility,'" *Time*, March 20, 1972, pp. 72–77

Matthais, Rosemary. "Pat Steir: Paley & Lowe," *Arts Magazine*, vol. 47, no. 2 (November 1972), p. 68

Welish, Marjorie. "New York Letter," *Art International*, vol. 16, no. 10 (December 1972), p. 69

1973 Forgey, Benjamin. "3 New Yorkers at Corcoran," *The Washington Star-News*, November 26, 1973, p. C4

Richard, Paul. "Homage Paid to Nameless Gods," *The Washington Post*, November 13, 1973, p. E7

Tucker, Marcia. "Pat Steir: 'The Thing Itself, Made by Me,'" *Art in America*, vol. 61, no. 1 (January–February 1973), pp. 70–74

1974 Heinemann, Susan. "Pat Steir, Joan Snyder, Institute of Contemporary Art, Boston," *Artforum*, vol. 13, no. 4 (December 1974), p. 75

Taylor, Robert. "Joan Snyder and Pat Steir: The Outer World and the 'Inner' Self," *Boston Sunday Globe*, October 6, 1974, p. 81

1975 Andre, Michael. "Pat Steir," *Art News*, vol. 74, no. 6 (Summer 1975), p. 144

Baker, Kenneth. "Pat Steir," *Arts Magazine*, vol. 49, no. 8 (April 1975), p. 21

Derfner, Phyllis. "New York," *Art International*, vol. 19, no. 5 (May 1975), p. 66

Ellenzweig, Allen. "Group Show," *Arts Magazine*, vol. 50, no. 2 (October 1975), p. 13

Heinemann, Susan. "Pat Steir: Fourcade-Droll, Inc.," *Artforum*, vol. 13, no. 10 (Summer 1975), pp. 75–76

Russell, John. "Pat Steir at Fourcade-Droll Gallery," *The New York Times*, April 5, 1975, p. 24

1976 Andre, Michael. "Pat Steir," *Art News*, vol. 75, no. 7 (September 1976), pp. 68–69

Brach, Paul. "Pat Steir: Xavier Fourcade Gallery," *Artforum*, vol. 15, no. 2 (October 1976), p. 62

Crary, Jonathan. "Pat Steir," *Arts Magazine*, vol. 50, no. 10 (June 1976), p. 10

Henry, Gerrit. "Is New York Still the Artistic Place to Be?" *Art News*, vol. 75 (November 1976), p. 47

Lyons, Harriet. "Pat Steir: Interior Landscapes," *Ms. Magazine*, vol. 4, no. 9 (March 1976), pp. 34, 36–37

Russell, John. "Art: French Neo-Classicism Without the Arguments," *The New York Times*, April 24, 1976, p. 19

Tucker, Marcia. "Interview with Pat Steir," *Journal of the Los Angeles Institute of Contemporary Art*, no. 10 (March–April 1976), pp. 22–25

Wilson, William. "Downbeat Exhibition at Otis Galleries," *The Los Angeles Times*, September 6, 1976, part 4, p. 2

1977 Forgey, Benjamin. "The Whitney Biennial," *Art News*, vol. 76, no. 4 (April 1977), p. 121

Glueck, Grace. "Art People," *The New York Times*, January 14, 1977, p. C16

1978 Boorsch, Suzanne. "New Editions: Pat Steir," *Art News*, vol. 77, no. 3 (March 1978), p. 137

Buonagurio, Edgar. "Artists' Books and Notations," *Arts Magazine*, vol. 53, no. 3 (November 1978), p. 5

Cavaliere, Barbara. "Pat Steir: Droll/Kolbert," *Arts Magazine*, vol. 52, no. 9 (May 1978), p. 27

McFadden, Sarah. "Pat Steir at Droll/Kolbert," *Art in America*, vol. 66, no. 5 (September–October 1978), p. 118

Perrone, Jeff. "Pat Steir: Droll/Kolbert Gallery," *Artforum*, vol. 16, no. 9 (May 1978), pp. 57–58

"Prints and Photographs Published: Pat Steir," *Print Collector's Newsletter*, vol. 9, no. 4 (September–October 1978), p. 123

Raynor, Vivien. "Art: Pat Steir, the Expressed Self," *The New York Times*, March 10, 1978, p. C23

Schwartz, Ellen. "Pat Steir: Droll/Kolbert Gallery," *Art News*, vol. 77, no. 5 (May 1978), p. 186

White, Robin. "Pat Steir, Interview at Crown Point Press," *View*, vol. 1, no. 3 (June 1978), pp. 1–16

Zimmer, William. "Pat Steir: Droll/Kolbert Gallery," *Soho Weekly News*, March 16, 1978, p. 24

1979 Day, Holliday T. "Midwest Art, A Special Report: Indianapolis, Cincinnati, Dayton," *Art in America*, vol. 67, no. 4 (July–August 1979), p. 68

Nuridsany, Michael. "Pat Steir, une puissance magique," *Le Figaro*, November 16, 1979

Rickey, Carrie. "Beyond the Canvas … Artists' Books and Notations," *Artforum*, vol. 17, no. 6 (February 1979), pp. 60–61

1980 Cohen, Ronny. "Pat Steir: Droll/Kolbert Gallery," *Artforum*, vol. 18, no. 9 (May 1980), pp. 82–83

Glueck, Grace. "Pat Steir: Droll/Kolbert Gallery," *The New York Times*, February 22, 1980, p. 19

———. "Artists' Conference Alights at a South Seas Island," *The New York Times*, February 24, 1980, p. 44

Huntington, Richard. "*Drawings* Exhibit at Freudenheim," *Buffalo Courier-Express*, January 20, 1980, p. A8

Perreault, John. "Report from Micronesia Panoply in Ponape," *Art in America*, vol. 68, no. 5 (May 1980), pp. 35–39

White, Robin. "Pat Steir, un expressionisme réfléchi," *Art Press*, no. 18 (October 1980), p. 17

1981 Artner, Ellen G. "Art," *Chicago Tribune*, June 19, 1981, sec. 2, p. 12

Berntsson, Asa. "Konst som liv och manniska," *Sydsvenska Dagbladet*, December 7, 1981

Dickinson, Nancy. "Pat Steir: Vital Painting," *Rhode Island Review Magazine*, October 1981, p. 12

Foran, Jack. "Fine Show of Works on Paper in the Nina Freudenheim Gallery," *The Buffalo Evening News*, March 13, 1981, Gusto Section, p. 35

Horstfield, Kate. "On Art and Artists: Pat Steir," *Profile*, vol. 1, no. 6 (November 1981), pp. 1–22

Huntington, Richard. "Tough, Peaceful 'Paper Work' Show," *Buffalo Courier-Express*, March 15, 1981, pp. E1, E6

Laurent, Rachel. "Pat Steir," *Art Press*, no. 46, March 1981

Levine, Melinda. "Layers, Marks and Hypnotic Regression," *Artweek*, vol. 12, no. 41 (December 5, 1981), pp. 1, 16

Phillips, Deborah. "Pat Steir: Max Protetch Gallery," *Arts Magazine*, vol. 55, no. 8 (April 1981), p. 29

Rogers-Lafferty, Sarah. "Arbitrary Order: Paintings by Pat Steir," *Dialogue: An Arts Journal*, January–February 1981, p. 51

Russell, John. "Met Unveils Treasures of Islamic Golden Age," *The New York Times*, November 20, 1981, p. C28

Shere, Charles. "Steir Show Opens New Crown Point Gallery," *Oakland Tribune*, December 24, 1981, p. C3

Zimmer, William. "Furniture Outlets (or, Formica Follows Function)," *The Soho Weekly News*, December 1, 1981, p. 48

1982 Casademont, Joan. "Pat Steir: Max Protetch Gallery," *Artforum*, vol. 20, no. 6 (February 1982), p. 85

Castle, Ted. "Pat Steir and the Science of the Admirable," *Artforum*, vol. 20, no. 9 (May 1982), pp. 47–55

Frank, Elizabeth. "Pat Steir at Max Protetch," *Art in America*, vol. 70, no. 3 (March 1982), pp. 143–44

Goldman, Judith. "Woodcuts: A Revival?" *Portfolio*, vol. 4, no. 6 (November–December 1982), pp. 66–71

Navone, Edward. "Art and Words," *Forum*, April 1982, pp. 10–11

Phillips, Deborah C. "New York Reviews: Pat Steir (Max Protetch)," *Art News*, vol. 81, no. 2 (February 1982), p. 164

"Prints and Photographs Published: Pat Steir," *Print Collector's Newsletter*, vol. 12, no. 6 (January–February 1982), p. 182

Silverthorne, Jeanne. "The Pressure to Paint, Marlborough Gallery," *Artforum*, October 1982, pp. 67–68

Simon, Joan. "Expressionism Today: An Artists' Symposium: Pat Steir," *Art in America*, vol. 70, no. 11 (December 1982), pp. 74–75

1983 Ahlander, Leslie. "Lowe Offers Triple Passage Through Time," *Miami News*, December 16, 1983

Baker, Kenneth. "Pat Steir's Paper Roses," *Boston Phoenix*, March 22, 1983, sec. 3

Champey, Ines. "Pat Steir," *Art Press*, no. 67 (February 1983)

Curtis, Cathy. "Without Illusions," *Artweek*, vol. 14 (April 23, 1983), p. 4

Johnson, Patricia C. "Teaching Herself, Others," *Houston Chronicle*, June 12, 1983, Zest section, p. 24

Kalil, Susie. "Art: Pat Steir's Paintings, Prints, Drawings," *The Houston Post*, June 12, 1983, Section F, pp. 1, 9, 10

Kohen, Helen L. "Lowe Shows Art Made in America," *Miami Herald*, December 11, 1983, p. L5

Mays, John Bentley. "Steering Clear of Painterly Hot Sauce," *The Globe and Mail*, March 11, 1983, p. E8

Muchnic, Suzanne. "Richards, Steir Speak an Intimate Language," *Los Angeles Times*, April 11, 1983, Part VI, pp. 1, 4

Temin, Christine. "Three Roads from Here to Infinity," *Boston Globe*, March 31, 1983, p. 62

Twardy, Chuck. "Talks to Study 'Print Life Cycle,'" *Lawrence Journal-World*, January 30, 1983, pp. B11–12

Wechsler, Max (translated from the German by Martha Humphreys). "Zurich: Pat Steir, Galerie Annemarie Verna," *Artforum*, vol. 21, no. 8 (April 1983), pp. 82–83

"Women Artists," *Bilutsu Techo*, vol. 35, no. 515 (September 1983), pp. 82–83

1984 Arthur, Alan G. "Art Galleries—Shorr: Altering the Aim of Photography; Pat Steir," *Chicago Tribune*, March 16, 1984, Section 5, p. 16

Banister, Amy. "Pat Steir Exhibit Opening at CAC," *Forum: A Women's Studies Quarterly*, Winter 1984

Brenson, Michael. "Art: Pat Steir's Brueghel Series," *The New York Times*, December 14, 1984, p. C33

Castle, Ted. "Pat Steir: Ways of Marking," *Art in America*, Summer 1984, pp. 124–29

Findsen, Owen. "Reorganization Gives Artist Vision," *Cincinnati Inquirer*, February 5, 1984, p. D18

Glueck, Grace. "Beauties and Beasts at the Pratt Gallery," *The New York Times*, April 6, 1984, p. C28

Green, Judith. "Opposites Attract in 2-Artist Show," *Cincinnati Post*, February 9, 1984

Hayden, Harold. "Mid-Season Offerings Are Rich with Diverse Styles," *Chicago Sun-Times*, March 2, 1984, p. 58

Howell, George. "Steir's Paintings Are Quietly Non-Violent," *The Buffalo News*, October 18, 1984

Rubin, Michael G. "Works of New York Artist Displayed at Signet Gallery," *St. Louis Globe-Democrat*, February 25, 1984

Russell, John. "The Image of the Buddha Continues to Enthrall," *The New York Times*, December 2, 1984, Section 2, p. 29

"Pat Steir," *Tableau*, vol. 7, no. 2 (November 1984), p. 88

"Pat Steir in bloei dank zij Van Gogh," *De Telegraaf*, November 23, 1984

Simons, Riki. "Drieluiken als eerbetoon aan Van Gogh," *NRC Handelsblad*, November 21, 1984

Weinstein, Jeff. "Art: Sex," *Village Voice*, December 18, 1984, centerfold

Wingen, Ed. "Pat Steir en Osvaldo Romberg," *Kunst Beeld*, November 1984, pp. 44–45

1985 Borrini, Catherine France. "L'Oeil du maître," *L'Hebdo*, April 4, 1985, p. 64

————. "Promenades en sculptures," *L'Hebdo*, June 6, 1985, pp. 60–61

Brenson, Michael. "Critics' Choices: Art," *The New York Times*, April 21, 1985, Section 2A, p. 2

————. "Flowering Plum—Chinese Motif for the Passing of Beauty," *The New York Times*, June 2, 1985, Section 2, pp. 29, 31

Castle, Ted. "What Was on in New York," *Art Monthly*, no. 84 (March 1985), p. 2

Greenspan, Stuart. "Pat Steir: The Brueghel Series (A Vanitas of Style)," *Art & Auction*, vol. 7, no. 7 (February 1985), pp. 56–59

Groot, Paul. "Pat Steir's Brueghel Series," *Museum Journal*, 1985, no. 3, pp. 164–68

Indiana, Gary. "Art," *The Village Voice*, March 5, 1985, p. 83

Larson, Kay. "Privileged Access," *New York Magazine*, July 22, 1985, pp. 61–62

McEvilley, Thomas. "I Think Therefore I Art," *Artforum*, vol. 23, no. 10 (June 1985), pp. 74–84

————. "Reviews," *Artforum*, vol. 23, no. 8 (April 1985), pp. 92–93

Paine, Sylvia. "A Vanitas of Style," *Arts*, April 1985, pp. 11–13

"Pat Steir: de 1981 à 1985," *Tribune de Genève*, March 29, 1985

"Pat Steir: Galerie Eric Franck, Genève," *Art Press*, no. 92, p. 56

Raynor, Vivien. "Art: Contemporary Drawings at the Modern," *The New York Times*, July 5, 1985

Woodville, Louisa. "Three Painters, Three Decades," *Arts Magazine*, vol. 59, no. 5 (January 1985), p. 19

List of Plates

Page numbers are in *oblique* type.

Photograph Credits

Jon Abbott, New York: 126
M. L. Bachmann, New York: 116-19, 125
Galeria Marilena Bonomo, Bari: 120, 121
Centre d'Art Contemporain, Genthod, Switzerland: 110
D. James Dee, New York: 79, 80, 83, 85, 88, 94
Dumont-Landis Fine Art, New Brunswick, New Jersey:
 124
Galerie Barbara Farber, Amsterdam: 107
Galerie Farideh Cadot, Paris: 61, 74, 87
Ron Forth, Cincinnati: 24, 27–29, 31, 32, 39, 40–42, 45, 49,
 64, 67, 69, 76, 78, 84, 86, 100
Galerie Eric Franck, Geneva: 102, 123
Fuller-Goldeen Gallery, San Francisco: 44, 50
Rick Gardner, Houston: 89, 93, 104
The Harcus Gallery, Boston: 48, 91, 96, 105
Leslie Harris, New York: 72, 75, 90, 109
Michael Klein, Inc., New York: 82, 114
Barbara Krakow Gallery, Boston: 38
Peter Muscato, Brooklyn: 106, 108
The Museum of Modern Art, New York: 66
Eric Pollitzer, New York: 36
George Rehsteiner, Vufflens-le-Château, Switzerland: 70,
 81, 97, 98
Clive Russ, Boston: 113
Wolfgang Staehle, New York: 33, 35
Virginia Museum of Fine Arts, Richmond: 68
Whitney Museum of American Art, New York: 25